Aerial
2010
THE F WORDS

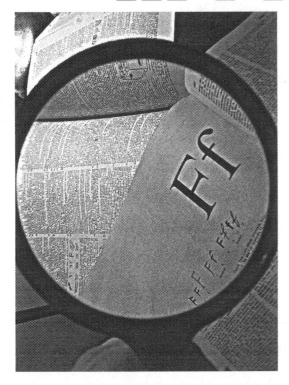

John Glenn's
Fine Arts Magazine

John Glenn High School
201 John Glenn Drive
Walke... Indiana 46574
Enrol...
Volur...

T0116926

"F," the sixth letter of the alphabet, is one of the 26 letters of the alphabet that helps to fill our minds and imaginations with the right words to express ourselves. Yes, thanks to comedian George Carlin's infamous seven words "you can't say on TV" and our "street vocabulary," THE F word has earned a bad rap, but the language of F words is so much richer, diverse, and expressive. Journey with our writers as we explore feelings and memories through the variety of our words.

Figments of the Imagination
Poetry Renga by Kelsey Piotrowicz, Kate Smith, Jessica Verkler, Kristin Whitaker, and Kelsey Piotrowicz
Photo by Kate Smith, Senior

The wind in my hair, my mind uninhibited,
I run free from life, completely blissful.
Imagination gives me the power to create worlds
and dream beyond the limitations of life.

Inside, I hear the tension.
I feel the stress rolling through the air.
Imagination gives me the power to dive beneath the waves
and create my own world.

In my mind I am free to dream
with my world laid out before me.

Reality is something I don't want to grasp,
where I am subjected to the confines of life.

I will dream whatever I want.
No one will stop me, my imagination.
I have the ability to do what I want
with the capacity to create.

I conceive a place of freedom from the clutches of life
where the soul is set free from its iron cage.
I am a fledgling; I fly.
How liberating it is to imagine!

The F Words
2010

AuthorHouse™
1663 Liberty Drive
Bloomington, IN 47403
www.authorhouse.com
Phone: 1-800-839-8640

First published by AuthorHouse 3/9/2010

ISBN: 978-1-4490-9605-2 (sc)
ISBN: 978-1-4490-9709-7 (e)

Printed in the United States of America
Bloomington, Indiana

This book is printed on acid-free paper.

P A T R O N S

Financial Friends

Platinum

Falcon 500 Club
Lochmandy Motors
Tri-Kappa, Inc.

Gold

Eileen Reed
1st Source Bank
JMS Insurance Group
McCormick Electrical Services, Inc.
New Kitchen Store
Teacher's Credit Union
Tom and Debbie Walter

Bronze

Bob's Country Store
Glenn Wisnieski, DDS
Hamilton's Service Center
Just for You
Preferred Auto
Subway
Ted and Karyn Hesters' Jersey Cattle

Boosters

Animal Hospital of North Liberty
Barry's Photography
Don Eberly
Keith Baker, Pioneer Seed
Kerry Knape, DDS
Liberty Lanes
Lucky Mart
Ponderosa Steakhouse
Walkerton Police Department

A E R I A L S T A F F

Freelance Writers and Fabricators

editors	Kaitlin Cassady, Kayla Goforth, Breanna Kretchmer, and Kelsey Piotrowicz
art editor	Kate Smith
editorial staff	Megan Beery, Kate Carlson, Kaitlin Cassady, Josh Christie, Chantell Cooper, Mark Davis, Erik Frankiewicz, Kayla Goforth, Lauren Kipper, Breanna Kretchmer, Autumn Ladyga, Audrey Mahank, Adam Novello, Kelsey Piotrowicz, Kate Smith, Megan Snyder, Jessica Verkler, and Kristin Whitaker
design and layout	Kayla Goforth, Breanna Kretchmer, Kelsey Piotrowicz, Kate Smith, and Jessica Verkler
art advisors	Mr. John Thomas and Mrs. Amy Hughes
aerial and literary advisor	Mr. Paul Hernandez
administration	Superintendent Richard Reese Principal William Morton Assistant Principal Chris Winchell
printers	AuthorHouse 1663 Liberty Drive, Suite 200 Bloomington, Indiana 47403 Kristoffer Poulsen, Book Consultant Adalee Cooney, Production Supervisor

- The F Words -

C O N T E N T S

Features

fiction

drama

prose

poetry

C O N T E N T S

C O N T E N T S

FOUNTAIN OF YOUTH

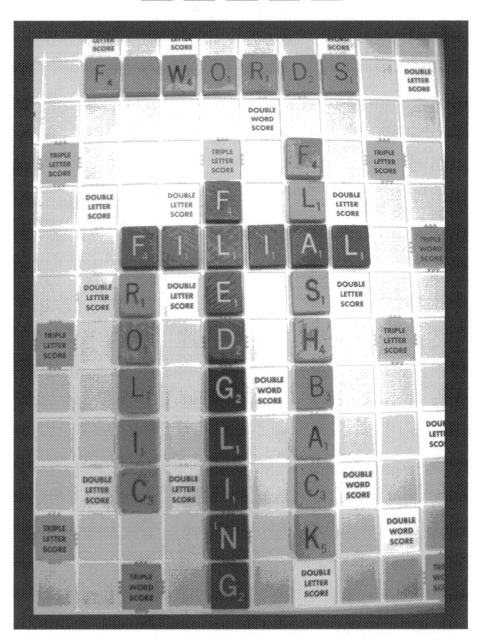

*Feeling nostalgic? The **Fountain of Youth** is just one of many F words that can fill our minds with memories of childhood, growing up, and the positive and negative lessons learned. Follow our writers and artists as they focus on friends, fun, family, folklore and the freedom of youth.*

Time Unbending

Poetry Renga by Mark Davis, Erik Frankiewicz,
Kayla Goforth, Megan Snyder,
and Chantell Cooper
Tempera by Mariah Rippy, Sophomore

Alley ways and new concrete,
children play upon the street.
Too old now to join in play,
No Fountain of Youth,
For even one day.

Jumping rope and skipping stones,
Bright red, plastic telephones,
Whispers to a dearest friend,
I want to be a kid again.

Climbing trees,
Running from bees,
Laughing at thoughts of these
Is now only fantasy.

'Once upon a time' and princess castles,
Blanket forts and bath time hassles,
All these playtime games I play,
But only in a mental way.

Days of youth I now remember,
Each day was a new adventure,
Never done and never-ending.
Too bad time is so unbending.

The Playground

Poetry Renga by Jessica Verkler, Kristin Whitaker,
Kelsey Piotrowicz, Kate Smith, and Jessica Verkler

Running across the playground,
 pebbles flying through the air,
 kids run around and make their own fun.

Swings glide back
 and
 forth,
seesaws slam against the ground,
faint cries come from the jungle gym.

The merry-go-round with a load of passengers,
off in a dizzying spiral,
their thoughts and stomachs along for the ride.

A crash to the ground,
someone lost to the monkey bars,
triumph and pain in youthful sounds.

Life was easier on the playground.
The world made sense and...
everyone was free.

The Morel

A Lesson for Life

Prose by Alyssa Wiegand, Senior
Photo by Karen Celmer, Senior

Ah, the morel mushroom.

A fine specimen of the fungal kingdom, an elusive treat, and a memory maker extraordinaire. Although the turd-colored, wrinkly fungal growth doesn't look particularly appetizing, it really is the brown gold of the back roads. It's usually coated in flour and fried to a crisp in butter, or at least that's how our family has always cooked the delightful mushroom. I'm getting ahead of myself; first, you have to hunt the mushrooms!

When you hunt for mushrooms, you have to be quiet. I'm not sure why, but when my family hunts, we're always quiet. Perhaps we'll scare the morels away. While hunting, you have to squint really hard at the ground, leaving no leaf unturned, no nook unsearched, hunting near elm trees and in lucky spots from the year before. True morel hunters know that you cannot, under any circumstances, utilize a plastic bag. Morels make spores, and if their spores don't escape, they don't make baby mushrooms for the next season. That would be a tragedy! You can't walk too fast when hunting either, because morels always like the little out-of-the-way-of-your-eyes hiding-holes that are almost always in the way of your feet. My grandma, uncles, dad, and mom have imparted all these tricks of the trade to me. We all hunt together in the spring to insure optimal eating pleasure, and these hunts are some of the best times I can remember with my family.

As we tiptoe through the forest, with the occasional shout of victory, we all bond. This bonding carries over into the kitchen where each morel must be carefully trimmed, washed, and fried. Throughout the process, we all have fun and tease each other. I try to absorb all of these moments as they come because life has a way of carrying on without your consent, and you can't stop it; you just relish the details and accept what you can't change. These are the lessons morels have taught me: Pay attention to details, talk softly, carry a big bag, and remember these times, because they may not always be there when you look next.

Lazy Summer

Poetry by Jordan Myer, Junior
Charcoal by Anna Schmalzried, Sophomore

Down the bank to the river,
water slow flowing,
wet sand beneath my toes.
Birds singing, fish jumping, frogs croaking,
as boats gently flow down the river north.
Tree leaves rattling in the soft cool breeze
take me back to the lake on hot summer days,
swimming beyond the dock.
Swimming down and down through the weeds
into the cold pockets of water just above the clay floor,
staying down until my chest's so tight then
coming up for air, reaching for the surface.
Grandma calls me for supper.
I get up off the sand and race
my brother up the bank for burgers.

CATCH THE SCENT

Prose by Nicole Noland, Senior
Photo by Kate Smith, Senior

There are only a few scents that can really trigger a memory for me. In fact, I can probably count them all on one hand. None of them are the typical, romantic, reminds-me-of-my-first love fragrances. They're actually quite the opposite. More of a "wishing I could go back to" kind of feeling. Reminiscence, I believe the word is.

The smell of paint thinner diluted with water, sends me back to my grandparent's boat on Lake Michigan. Water spraying in my face with the July sun turns my cheeks red as a lobster. In almost 18 years, I've yet to go an entire summer without a sunburned face. Hanging onto the sides of the rocking vessel with fistfuls of popcorn, I intended to throw it to the crying seagulls yet really ate most of it myself. It takes me back to running my hands through the wavy water, secretly pretending I was a mermaid and this was the ocean. I wished I could stay on that lake forever. We would wipe the sides of the fishing boat with paint thinner during the winter months while it was stowed away in my grandparents' enormous pole barn garage. When I got older, the magic of our trips seemed to fade a bit. The lake seems smaller now, but I still promise myself one day I'll live on a harbor.

The second most profound smell is Jovan Musk spray. Every day since my freshman year, I walk past Mrs. Fansler, and the smell of her perfume catches me. For a split second, in between taking another step, I'm 5 years old again, locked up in my Nana's bedroom, going through her dresser drawers, looking for makeup to play with. I'm sitting at her kitchen table, drinking cherry SqueezIts while her too-cold air conditioning blasts in my face. Falling asleep between the Little Mermaid sheets she bought me, I'd wake up to the smell of her "cooking" Pillsbury cinnamon rolls and sun tea.

I've been told I'm so much like her it's scary. She's to blame for my tea addiction. Standing side-by-side , we could be sisters, except for the whole age thing. Same hair color, though hers is a tiny bit more blonde. The workings of Miss Clairol in Summer Honey, no doubt. She's worn that perfume since I can remember. On any given day, I can walk into Study Hall, and just for an instant, I'll almost turn to expect her behind me, her over-sized purse in one hand, a Diet Pepsi in the other. But then, the smell fades as I walk farther, and I'm instantly brought back to reality again.

The third and probably most acute memory-triggering smell is, quite simply, the smell of hay. It doesn't matter what kind of hay, to

me at least. It has this sweet, grassy smell to it that sends images rushing to my head, flooding my mind with a decade of shared memories. Strings of words loosely connected to each other race through my brain as I inhale that natural perfume. Freezingcoldhorsewatermudpuddles
...
Horsesshampootanktopsprimer
...
Moviesrainshoppingpancakes
...

> "Strings of words loosely connected to each other race through my brain as I inhale the natural scent."

Unlike any other memories, I can define exactly what it is about hay that causes these thoughts. My best friend Nikki's barn is filled with hay. Just a slight whiff of it brings on the giggles that make my skin itch. To me, hay smells like spending an hour washing her horse, Silver, with special shampoo, ending up soaking wet with soap in both

our eyes, only to have him instantly get dirty again and relieve himself on my foot. Then we'd turn her living room into one big sleeping bag and fall asleep with the lights on, with the Horror Fest DVDs to blame. Or, waking up in a hotel to "The Carpal Tunnel of Love" blaring in my ears and her laughing when I fell off the couch. We'd shop in an outlet mall on a day so nasty no

one else would even dare drive out in it, then buy plaid fedoras for 25 cents and parade about all day in them. Hay. It's like Oreo cookies and lopsided pancakes burned on one end, liquid on the other. Like dancing down her staircase to the *Rent* soundtrack. Like creating stories about how we're really unknown rock star girlfriends and name-dropping like crazy to strangers. If you could bottle it, I'd buy it in bulk and wear it everyday. Each time I would put it on would be like something new. Laughing so hard at our own immaturity that it hurt, we'd talk in our own moronic language, where everything was an inside joke. We'd call it "Nicki Egand" or

something, because like everything else, we have to be paired together whenever humanly possible. It would smell like Wranglers, Cadillacs, Pentecostal churches, sparkling jewelry, chocolate and barrel racing. Like baby powder, oil pan, Fall Out Boy, eyeliner and the Phantom of the Opera.

Maybe to other people, paint thinner smells bad. Jovan smells like an overpowering cheap perfume that laces the aisles of Macy's and the fragrance counter at Kohl's. Hay might just remind others of allergies. I don't really care. I'll take any of the three over any expensive cologne any day.

You Always Knew

Poetry by Grace Ball, Senior
Pencil by Emilee Malkowski, Junior

I never really knew you,
but you were always there,
the smell of sweet peppermints
and strawberries in your hair.
Whenever I was sleeping,
a kiss on my forehead you would give.
I can't believe you're gone;
I thought you'd always live.

It seems like I can hear your footsteps
or see you in the corner of my eye.
Why did you have to leave?
I wasn't ready to say goodbye.
Can't you see my sorrow
from heaven up above?
Your soul leaps into me
like an elegant white dove.
I wanted to tell you
that my love is true,
though something in my heart
told me you always knew.

Grandma's Rocker

Prose by Ashley Bohnke, Senior
Pencil by Gilberto Munoz, Junior

She was beautiful in her old age. Wrinkled and white, you could always find her in her rocking chair. Watching <u>Wheel of Fortune</u> was the thing to do on late nights. We would go to her house on occasion to make sure she was still there. When you asked her how she lived so long, she would reply, "Just keep breathing," in her high pitched voice.

Her house was the best. All white with black shutters. It had a porch on the front with my favorite wooden swing. Lady, her dog, and I would sit on the swing, and I would sing to her words of my childhood. The house was big and had an apple tree in the back yard, perfect for a good throwing fight. All the kids in the family would go outside and run around playing and throwing apples at each other while the adults were inside "visiting."

Although my grandmother couldn't drive, she had two nice cars: one was my grandfather's who had long passed away, and one was hers. She got her hair done once a week, although she had no where to go and no one to impress but that old green rocking chair. She also went out to eat at the same restaurant with her mother and sister once a week. Although she lived alone and only went out once in awhile, she was happy, and you could always tell by the big smile you would always find on her face.

She lived in a little town surrounded by Amish duck farms. She was the only house on her road with a car and electricity. The Amish families around her would always bring her food and duck eggs in exchange for a couple minutes on her old fashioned telephone.

The best thing at Grandma's house was the candy. The first thing my cousins and I would do after we said our hellos was to get into the candy drawer and get a handful of candy. No matter how much candy we took, the next time it would always be full again. Even though grandma didn't eat candy herself, she always made sure her drawer was full for us kids to eat. It was the first and last thing we went for after saying hello and goodbye.

Grandma Edwards died when she was 99. I remember her funeral like it was yesterday. All of her family was there, and most of them I did not know. When I went to look at her in her casket, the only thing I noticed was her nose. It had a particular bump in it that I see everyday. I always wondered where my odd shaped nose came from, and I now know. Looking around the room, I noticed several others sharing the same characteristics she had. Some had her rosy red cheeks, and others had her wrinkly skin. When I look in the mirror, I not only see myself, but also my grandmother and all the memories I shared with her.

What doesn't kill you makes you stronger. In my family that saying applies mostly to my little sister, Marie. She hates getting hurt, but when you have an older sister with A.D.H.D. you can't fight the inevitable. To this day my family still rehashes all the incidents that, at the time, weren't funny. Yet now these incidents have become legendary.

Growing up, Marie and I played together all the time despite the fact that I was about five years older than she was. I was very creative, so I came up with lots of great things to do and some, not so great. The first incident that occurred was with the plastic highchair.

figuring out how to get the tray unscrewed, Marie was free.

Another one of my "fun" games I devised was "Houdini." Marie and I would take turns tying each other to a pole in our basement and then trying to escape. Of course, I was much better at this than Marie. She was too young to even tie her shoes; knots were foreign to her. I, on the other hand, was extremely good at knots. I let Marie go first and tie me up. Within seconds I was free, so Marie assumed this would be an easy game. Then it was my turn to tie her up. I made sure to tie all the knots super tight and wrap the rope around her a lot. I also made sure to

What Else Sisters

Prose by Amy Shirk, Senior

Oil by Kayleigh McMichael, Senior

Marie and I had been playing house in the basement. She was just a little bigger than baby-doll size. I decided she could fit in the play highchair, so I put her in. Everything was going great until I tried to take her back out. Apparently, it was easier to put her in the highchair than remove her. I yelled upstairs for Mom, and she came running down. This specific play highchair didn't have a removable tray; it had to be unscrewed. After 10 minutes of searching for a screwdriver and five minutes of

specifically use one shoe lace for each of her hands and feet. Once I was sure there was no way she could get loose, I turned off the lights and went upstairs to wait for Marie. Hours passed before Mom asked where Marie was. I told her, and she once again ran downstairs to find Marie sitting there crying.

Once Marie was a little older, I decided that she was old enough to go in the woods with me. I was really good at finding my way through our huge woods. I would run, jump over logs, and

cross the stream. I planned to teach Marie everything I could do, but she was very cautious and didn't have a sense of adventure like I did. The first time I took her with me, I told her to keep up, and I took off like a cheetah. For a little while she ran after me, but then she got tired and couldn't keep up. I kept running until I was out of breath, which took awhile. I turned around to see no one there. Suddenly, I realized that I had left Marie somewhere lost in the middle of the woods. I ran back to find her crying. She said she was scared and she didn't know the way back to the house. I stayed with her on the way back, and we eventually made it home

Are For?

just before dark.

When Marie was about seven or eight, I lost her again. It was a foggy Saturday morning, and we were all up early for some reason. There was a big row of massive pine trees way at the back of our hayfield, but that morning the fog was so thick, you couldn't even make out their silhouettes. Visibility was probably less than twenty feet. I thought it would be fun to go out in the middle of the hayfield, spin around, and then try to find our way back to the house. Marie and I put on our coats and headed outside. As we headed towards the middle of the hayfield, we walked backwards so we could watch our house disappear. When we reached the middle, I spun Marie around ten times really fast, and then I took off for the house. Marie was obviously disoriented. She wandered around for about an hour before I decided to go out looking for her. By then the fog had cleared a little. After searching for twenty minutes, I found her in our uncle's hayfield next to ours. She was crying a little, and I led her back to the house.

Marie is older now and wiser. She knows better than to close her eyes and open her mouth for a surprise. She also knows not to go look in the garage for a surprise, because I once hid a scary mannequin with a black wig in there. She has not died and is a strong person, so I guess the saying is true: What doesn't kill you makes you stronger.

That Wooden Spoon

"Tap, tap...tap...." A wooden spoon clicks against the plastic handle of a grocery cart. My wailing cry suddenly stops when I hear the clicking of the smooth object. I didn't fuss often, but if the occasion arose, that wooden spoon put an end to it. One swat on the rear with that solid instrument was enough to stop the tears, even just thinking about the wooden enforcer was deterrent enough.

My mom has never believed in raising "heathen children." The last thing she would tolerate is a stubborn, obnoxious child throwing fits at home, much less in public. I suppose these days, disciplining a child on the rear with an object such as a wooden spoon would be seen as a form of "abuse."

I see it as a way to keep disrespectful, out-of-control children from crowding every public place you walk into. Those little clicks ricocheting off of the grocery cart handle allowed me to become one of the most well-behaved children, knowing better than to test my mother.

Countering my mom's strict rules about behavior was her rendering humor. Comedy with balance, that is my mother. She was careful not to spoil any rules while finding joy in almost anything, then sharing that joy with me. Now we laugh more than we ever have, together, with knowledge of what is expected of me. I couldn't be more grateful for every "Tap, tap...tap" of that wooden spoon.

Prose by Kayleigh McMichael,
Senior
Photoshop by Kate Smith,
Senior

Mom

Poetry by Kelsey Piotrowicz, Senior

Pencil by Ariel Rensberger, Junior

Cerulean eyes, like pools of compassion, look through me.
She knows all, without knowing anything.
Beneath her sophisticated short tresses lies a cunning mind
Merged with charity and munificence.
Her voice rings to every passing person,
Inherently social- a positively and negatively charged trait.
She is adorned with vogue garments.
Her ears and thin fingers are ornamented with reminders of the past and present.
The smile upon her youthful, forty-something face is an amalgam of happiness, tragedy,
 longing, excitement, stress and reality .
The pace of her walk is that of her heart- always expeditious, an abundance of pep in her
 step.
A transformer. She fits every role for which she is called.
She is the vigor that unites the entity that is our family.
She is me in thirty years- a scary, but comforting thought.
My mom.

Summer Days, Summer Nights

Poetry by Emily Thomas, Junior

Oil by Kate Smith, Senior

The buzz of my cell phone announces her arrival one minute and seventeen seconds before I hear the sound of her pickup. It's a '94,

and it's rusty,

and it's beautiful,

and in all its splendor are three people of whom I am very fond.

A redhead (dyed), two brunettes and a blonde go out into the unknown of Indiana's wilderness: Plymouth's drive-in movies.

We pick up towels and candy and Welch's "red wine"-all hidden in the back. We drive to the end of the row for screen three. So many memories! So many deliriously silly laughs!

We return home after evading the cops from a different county and a few cute guys.

The buzz of my cell phone announces her arrival before my house alarm goes off. She parks her bike and walks through my door, welcoming herself in.

I straddle my brother's bike, since it goes faster, and we ride.

Pedaling with crackly mp3 speakers and our hands in the air, we sing along to the guitar. We hear thunder rolling and realize that, we passed my fields and are almost stranded. We duck into a neighbor's barn when the rain engulfs this small town.

We laugh and grab pop-ices from the freezer as we sit in white plastic chairs and watch the rain roll through the barnyard.

Our mothers call, and we ride home when the rain dies down.

The buzz of my cell phone announces her arrival before I smell the funnel cakes and hear the familiar hum of the LaPorte County fairgrounds. We trek off to the the rodeo, buying clothing because of the unseasonable cold.

Friction!

We don't need it because, low and behold, we meet up with a couple of bull riders to keep us toasty. We sweet talk our way into their trucks, getting names and numbers along the way. We have to leave when our parents beckon, but in a whirl, spur(he-he, get it?)- of -the -moment stoke of impulsiveness, we run to them and we make out like crazy.

"What's your name, again? What's my age again?" The sky, heavy with stars, sheds lights on our heart's desire. Gotta love them cowboys, but how 'bout them cowgirls?

I still remember the dust,

the taste of cherry pop-ice,

the phone call from a cop,

our eternal summer.

These are my prized possessions.

People say that I am lucky. I grew up with money. I have a big house, a happy family. I travel often. I get good grades. I'm pretty to some, being blonde, thin and smiling.

Material things mean nothing to me; I want you to know that. I am who I am because of you. I see myself as Emily, and words fail to describe me completely. I can only come close to describing myself through describing these encounters:

the sneak – outs,

the sleepovers,

the parties,

the movies,

the fairs,

the summers,

the friends.

My girls, my bffs, you are what I cherish. In this life one doesn't need money or things or luck.

One needs friends. I am

so

very

happy

that I can say that I can only be me when I am with you.

To our friendship, our summers and the rest of our lives, together and apart.

Question
Everything

Prose by Jacob Marek, Senior
Collage by Brooke Poeppel, Senior

Dead... One-dimensional... Lifeless... These are a few words I use to describe a nation of followers. A man who answers to the nickname of Wrath once stated, "Live hard, die hard, and love hard in between 'cause tomorrow ain't promised and today is slippin' away." I view this statement as a solid truth. There is no way of telling when all of this is going to be taken away. Imagine the joy of laughter, summer days spent with friends, the smell of perfume, food, or any other scent that sends your brain into a frenzy, or even that warming happiness of holding a loved one in your arms. Now imagine the black abyss of nothingness that follows. Tell me you don't want to "live hard, die hard, and love hard in between...."

I live with my heart on my sleeve. Doing so leaves me vulnerable to being taken advantage of. It has happened many times, but I always endure. I give everyone a chance. Who am I to judge before I know? More times than not, I am blessed with a good friend. One day I will meet the woman I want to spend my life with. None of this is possible when you turn a cold shoulder. I live with my heart on my sleeve.

Gone are the Honor and Loyalty of the days of old. In the days of old, warring kings could meet face to face without fear of treachery. They held themselves with Honor. In our world, it is every man for himself. Those who claim to be men bring guns to fist fights. I am not like these men. If I give you my word, you can be sure I will honor it. It is those who carry themselves with honor who truly succeed in life.

I complement honor with loyalty. I am loyal to my friends and family as they are loyal to me. My friend Clayton and I recently went through a tough time. We were loyal to each other throughout the entire process. When I am with a girl, I am loyal. I do not see the point of cheating on someone. When you are loyal, there is a sense of trust. It is comforting to know that somebody has your back.

Question society as a whole. Why must I act as the media tells? I am told to follow and obey like a dog. When I do not, I am punished for my actions. I question each and every day why others are so blind. After years of being told how to behave, they stop questioning. They are scared of the potential backlash of being different. This eats at me. With only a year left of high school, society has me in its scope. I intend to look down the barrel every day and say good luck. It's going to take a lot more than a book, the media, or even my peers to change who I am. Be your own person; question everything.

I am very simple yet complicated at the same time. I hope you are similar in that you are not one-dimensional. I leave you by saying, "Life throws many a situation at you. How you are prepared to handle those situations is up to you."

Prose by Kate Jenkins, Senior
Pencil by Kate Smith, Senior

"Anyway dude, I'm telling you I'm pregnant, and you're acting shockingly cavalier."

The voice of the infamous Juno Macguff, star of the surprisingly popular indie film *Juno*, filled the dark theater. I pondered this line for a second, realizing I had never before heard the word "cavalier" used as a modifier. When used as a noun, the word resurrected a pompous, middle-aged soldier sporting a ridiculous, amber-toned mustache. He wore a blue uniform not unlike those worn by the Union generals of the Civil War, proudly gallivanting about the realms of imagination on a noble white steed.

The dictionary defines cavalier as "a horseman, esp. a mounted soldier; knight," so, in a sense, the picture in my mind was correct. But as a modifier, the word cavalier means "haughty, disdainful, or supercilious," in addition to "offhand or unceremonious." I assumed the first time I heard the word used in this manner would probably be the last, but surprisingly enough, I heard it used to describe someone yet again while listening to an album by one of my favorite bands, Dashboard Confessional.

"I'll be true, I'll be useful, I'll be cavalier," sang Chris Carrabba, the band's lead singer and songwriter. Hearing the word again struck me as ironic; I remember smiling to myself the first time I listened to the song.

The experience of hearing a new word or, in this case, an old word used in a new way, is an interesting one. The second the word is heard, the brain makes connections using a variety of seemingly random things. And suddenly, a definition has been created using already known facts to create something that couldn't possibly be known otherwise. Yes, this definition is often incorrect, but also usually more entertaining and creative than reality.

CAVALIER ATTITUDES

The Color of Friendship and Death

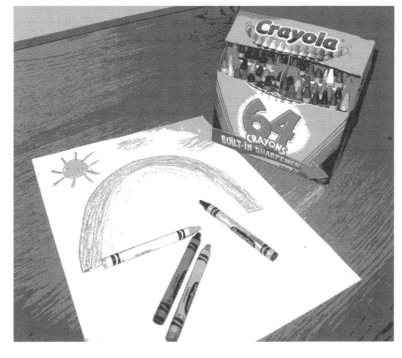

Poetry by Kayla Goforth, Senior

Photo by Kate Smith, Senior

The color draining from her body,
peachy looking, soft skin to a ghostly white.
The touch gets colder every minute.

Crying at the sight,
I look out the window and
see the beautiful purple, blue and orange sunset.
It reminds me of my favorite colors,
of the Crayola crayon box from kindergarten.

Ah, kindergarten, the first time we met.
She was my best friend, so carefree and full of life
back then, and now she is fighting for her life,
fighting this cancer that she didn't know existed.

I look away from the peace outside my window
to the now peaceful person I sit next to.
The color is fading from her face and hands, but
I will always remember her vibrant colored eye shadow and
that pink blush she always wore,
my best friend and the colors around her.

The HEADBAND

Prose by Jessica
Figueroa, Senior

Photo by Jessica
Figueroa, Senior

I'm about to go to the mall. To look my best,

I want to wear something nice. So after work I go home to get changed. I'm still unsure of what to do with my hair. I rummage through my room looking for a hair tie, but find something that shakes me to the very core; it is my old headband.

This piece of white plastic is smooth and shiny still, even after having it for three years. On the inside there are little bumps lined up perfectly. I run my fingers over them. It feels like the top of Lilliputian soldiers helmets all lined up. It has circular holes big enough to look through, like a pair of binoculars. I put this half moon on my head, and it doesn't hug too tightly nor fall like the moon does in the morning. It hugs my head perfectly and stays as long as I want it to.

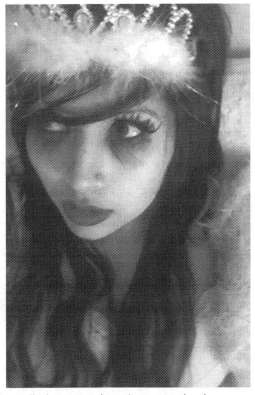

Thinking back I remember the day I got this special gift. It was a hot summer day, July 5, 2007, my 16th birthday. My best friend, who is like a blood sister to me, and I went to the mall. It was a tough birthday for me. Mom had called me earlier that day to inform me that we had been robbed. They had withdrawn every penny out of her bank account. It was going to be a bad day for me. While my friend and I were at the mall, she attempted to buy me clothes, CD's, movies, shoes, hair dyes, and virtually everything she thought would be of interest to me. But I refused everything. I was really bummed out. While I sat on the bench with my head down feeling sorry for myself, I didn't realize what she was doing. She and I made our way back to the silver SUV, and while we got in, she pulled out something. It was simple, classy, yet very meaningful. This gift was the headband that would eventually be my only memory of the one person who has touched my heart.

I began to think of how this headband reminds me of so many things about our friendship. We had a very honest friendship which represented purity, and the head band is white. The holes through it are like how we could see right through each other. If there was something wrong, we would notice right away, no matter how hard we tried to hide it. The saddest part when I look at it closely and examine it is I notice that this band could be a ring, but the ring was not finished. There is a beginning and an end. It is then I realize that something good always comes to an end. Our friendship is like this headband; there is a beginning and an end.

I remember that my sister is outside in her car waiting for me, so I run to the bathroom and put the headband on my head. Feeling it clasp my head gently always reminds me that there is still good in life. Knowing this and feeling this, I smile inside. When I look in the mirror, I notice my face is smiling, too, staring back at me.

Distant Horizons

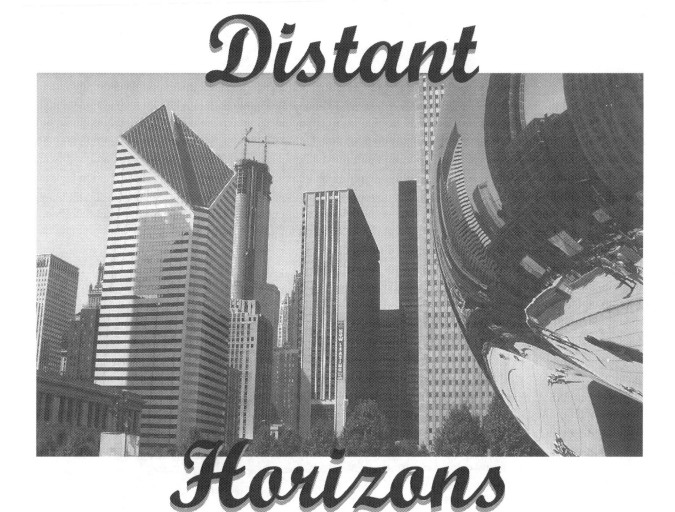

Fiction by Kate Jenkins, Senior
Photo by Chloe Bugajski, Senior

"**Dad,** I'm trying to listen, but that fish is staring at me," Anna said, a smile playing on her lips.

She rarely entered this room, his room, his domain. Her father slept here, but she couldn't help but see that space as more of a walk-in trophy case. A fisherman at heart, his most impressive catches were mounted on the wooden plaques around the room. The most intimidating one, a largemouth bass he referred to as "Chuck Norris," was clearly eyeing her.

"She's a beauty, isn't she?" he said. Turning in his chair to look at it for what must have been the millionth time, Anna could tell he was somewhere else. His deep blue eyes become glazed over, and she imagined him reliving every aspect of the catch once again.

"Anyways Dad, before you get too lost, what did you want to talk to me about?" he took a deep breath and turned to face his seventeen year old daughter.

"Anna, I don't know if you remember this, but last week I was early to pick you up from your dance lesson, and I finally got to watch you dance. It was only five or maybe ten minutes, but it was enough to see how good you have become and how much you enjoy it."

"Thanks dad! But...where is this heading? I'm kinda confused."

"Just wait a second! You're so impatient, just like Tahlia was." He smiled and was overcome by that

faraway look once again. Anna pulled back her thick brown hair and was struck with a painful emptiness she felt whenever her mother was brought up in a conversation. She died in a car accident when her only child was two years old, which the infantile Anna wasn't old enough to remember.

After a considerable silence, Anna longed for a return to the lighthearted mood of few minutes prior.

"Okay, I'm sorry. I'll try to sit here and do that thing you're always talking about.... you know, just listening." Her dad laughed and continued on. "Anyways, a few days ago, I was offered a promotion at work. It means a lot more money, but it also means a move...a move to Chicago."

Her eyes widened, and she inhaled sharply. Finally, the dots seemed to connect, but she didn't interject; her father was just getting started.

"At first, I wanted to say no. We have our life here, in this little town on the coast of Oregon....in this tiny bubble. I mean, you know I love it here; I love being able to fish in my backyard, and I love the friends we've made here. I can't forget all the kind people who have helped me raise you."

The suspense was already too much for Anna to handle. Her dad was right; she was anything but patient.

"So...you didn't take the job?" she asked, eyebrows raised.

"Well, I'm getting there, Anna! Like I said, I didn't think I would say yes. But then I remembered watching you dance. And it made me realize a lot of things; mostly that you need to be somewhere you can make the most of your life. Next year, you'll be thinking about college, and I have no doubt in my mind that you can get into Julliard. I know that's what you want; your face lights up whenever you talk about it. In Chicago, you can start taking some real classes instead of this novice YMCA crap you've been breezing through. And that, plus the fact that I'll be making a bit more money, made me decide to take the job."

Silence enveloped the room. In this moment, so much could be said, but Anna chose, for once, to say nothing. She didn't speak; she didn't cry. She simply met her father's gaze and nodded as if in a trance. The prospect of opportunity in her sole passion was breathtaking in itself, but her excitement was quickly swallowed by fear.

"Anna? Are you all right?"

"Honestly, I'm not too sure. I think I'm just gonna go outside for now."

Turning gracefully on her heels, she left her father alone at his desk and decided to stop by her room before doing anything else. There was something she didn't want to leave the house without.

A few minutes later, she emerged from the house sporting her worn ballet shoes. She sat on the end of the dock in their backyard and let her feet graze the surface of the cool Pacific Ocean water. Summer on the coast accentuated the striking green of the pines, as well as the overall beauty of the landscape; purple mountains stood proud in the distance, and slightly capped waves brushed the bottoms of the enormous rocks that bouldered the ocean front.

Just as she was fading into the surrounding nature, a car rumbled to life, catapulting her back in to the real world. She saw her father's blue Toyota Camry speed away towards town, and immediately, she speculated that he was headed to The Peg Leg, a local bar he had become quite fond of after meeting her mother there years ago. By now, Anna knew that whenever he was the least bit stressed, he either went fishing or had a couple of drinks at The Peg Leg.

After a relative peace had been established once again, Anna let her thoughts take her. She scanned the water, wishing for a fleeting moment that she was a mermaid. They seemed to represent all that was beautiful and free; a people who had no time to worry about trivial things such as moving from one place to the next, but were concerned only with the rush of the water and the colors glistening upon their fins.

What was Chicago to her, anyway? She envisioned a gray metal land, shrouded in the fumes of smokestacks, unnatural and in no way pure. But behind the fumes, she knew the opportunities existed, lurking in the background like elusive fairies. To realize them, she would have to look past all she had ever known, leaving the familiar behind like a discarded candy wrapper. Anna looked to the sky and felt the tears roll down her cheeks. She would never forget what she had learned up to this point; she would only use it to better herself under new circumstances. Her spirits lifted, and her mind began to race. Although the fear of the unknown weighed heavily upon her, the thought of the future, that no possibility was eliminated, seemed to enchant her.

"Change is progress," she whispered to herself.

She sprung to her feet and took the first shaky steps to another place, something new, something daunting, but above all, something better.

Truckin' With Dad

Prose by Ariel Beatty, Senior

Photo by Kate Smith, Senior

Since I was seven,

I could name all the buttons and levers on a semitruck and trailer. Since the age of sixteen, I have been able to attach a trailer to an actual semitruck. I can show you how to push the clutch in, but I have to use all my might to do it. I can tell you the quickest way to get to Louisville, Kentucky, and I can't tell you how many times I have seen some of the biggest buildings in America. My dad is a truck driver, and when I was a little girl, my favorite thing to do was go with him on his trips across the Midwest and parts of the South.

I would get so excited when my dad told me Sunday mornings that I could go with him for the next few days. I would talk to my mom about it, and she could hear the excitement in my voice as I packed to be my dad's little truck driver. I would pick going over the road with my dad over going to a friend's house any day. He would make it seem like it was all one big party, and we would go to Wal-Mart at two a.m. to get sweets and sandwich foods. We would be one of the few people there that late, and that made it seem like an entirely different adventure.

I remember trying to stay up all night so I could be awake at the same times he was. I wanted to keep him company and make sure he wasn't bored, so he didn't fall asleep at the wheel. When I would look over at him, while I was bouncing in the passenger seat, he would look tired, and I would tell him to think there was a cheetah right behind him, and if he fell asleep, the cheetah would get him. I remember having races on the adjustable seats and laughing so hard, we almost had to pull over numerous times. I also remember the "hilarity" of me having to pee so badly, and he would drive slower when we reached the rest stop, and I would hop out of the door before he had it in park. The thing I remember most though is how we smelled when we got home at the end of the week.

When I couldn't go with my dad, I was so eager for him to get home. The second he walked in the door, I ran up to him, hugged him tightly, and inhaled the smell of him deeply. The smell would linger right beneath my nose for the next five minutes. He smelled of grease and oil, not the best smell

in the world to some people. He would always tell everyone to wait for him to take a shower before we all jumped on him, but I couldn't. He just smelled too good! I also remember him coming home and having oil stains on his clothes and sometimes on his face and hands. When I washed these clothes, I wouldn't want to put fabric softener on them, so they still had his scent and I could smell him longer. When he would get home and was too tired to take a shower right away, he would sometimes fall asleep for hours, wake up, then take a shower. The next night he left, I would steal his pillow and sleep with it so I could smell that wonderful scent all night.

A few years ago, he got a new job, and he is still gone during the week, but he stays in hotels, making the smell wash away with his daily showers. His semitruck doesn't smell of it anymore either. When he comes home now, he smells of his cologne, not the sweet smell of grease and oil. I miss that smell. I miss my dad being all dirty and greasy when he comes home. Most of all, I miss my favorite smell in the entire world.

- The F Words -

Railroad Tracks

Poetry by Erik Frankiewicz, Senior
Photo by Kate Smith, Senior

The words have rhythm; they have flow.
Find your pattern and they will go
Like railroad tracks; one after the other
Mother, Father, sister, brother,
Amazed as pens and pencils clatter.
Inspiration. Constant chatter.
People watching, keeping time
In awe of what you do with rhyme.
Emotions filled with tears and laughter,
Thoughts are coming ever faster.
Even though the dreams are gone
The poems travel ever on,
Like railroad tracks...

Industrial

Poetry by Erik Frankiewicz, Senior

Rapid, running, hopping fences,
Flipping, spinning gears and cogs.
Jumping rooftops, welding torches,
Worn out turn-springs, junkyard dogs.
Twirling, honking, flashing metal,
Rusted iron, twisted steel.
Stopping, going, chains and dead bolts,
Happy pipe-dream, psuedo-real.
Hammers, wrenches, clanking steampipes,
Nails and washers, bolts and screws.
Circuit boards and cooling units
Filled with binary cues.
Linear accelerators,
People learning ever more.
Tesla coils, robot workers
Lined up on the factory floor.

The Youngest Adult

Prose by Joy Miller, Senior
Colored Pencil by Kirsten Brown,
Sophomore
Scholastic Art Gold Key Award

Have you ever noticed that sometimes the most mature person in the room is also the youngest? On occasion, the first person to grow up is also the youngest. I have a cousin named Gabe who, as of right now, is four years old. Gabe is way younger than the rest of his cousins, but mentally he could easily be the second oldest.

Allow me to inform you a bit about Gabe's life so that you can better understand him. He lives on a small time farm in Tomah, Wisconsin, with his oldest brother and both his parents. Up until about age three, Gabe spent everyday at his grandparents' house where he was babysat. The year he turned three, both of his

grandparents and two of his close cousins were in an accident and died. For quite awhile after the incident, Gabe continuously asked for both grandparents. Each time it was explained to him that they were not coming back. He still did not understand.

The day I learned Gabe is as intelligent as he is almost depressed me. That day was slightly different than most days on the farm; that day we were sending one of the cows to the butcher. In order to send the cow, it had to already be dead. Foolishly, while my uncle was shooting the cow, Gabe was watching with his sister. When the cow fell to the ground, Gabe started crying. I took him in the house to play with

his toys and tried to distract him.

We were in the house sitting on the living room floor when Gabe looked at me with an extremely serious expression. He told me, "The cow is dead. It's not coming back." I told him, yes, he was correct. I expected him to go back to playing, but he didn't. He had more to say. He said, "Grandma and Grandpa are dead." He didn't expect me to answer him. It was simply a statement. After that, he went back to playing and never asked for either grandparent again. I knew that inside his head something clicked. I also knew he was the youngest adult I have ever met.

Feet

Poetry by Patricia Weiss, Senior
Tempera by Samantha Palmer, Sophomore

No one has the same two feet as another person.
They have different shapes, sizes,
colors and destinations.
Each pair of feet will lead a person
down life's individual path.

Kate's feet are small and graceful.
She runs like an antelope,
with speed and agility.
On the soccer field, she's free like a bird.
Her feet help her to find her release.

Kelsey's feet are bigger, but quick like a jack rabbit.
One can tell that she was a tap dancer.
They glide across the stage
like the ripples on the surface
of a backyard pond at dusk.

Emily's feet are tiny and cold.
They are the only part of her that can
hide her emotions. In her bizarre shoes,
they stumble to find the path that can
truly lead her to happiness.

Natty's feet are immense and powerful.
They show people that he demands respect
and will get that respect without saying a word.
His feet will lead him to success,
no matter what path his feet take.

No two feet are the same,
just as no two futures are the same.
Each person has a unique destiny.
My feet are still stumbling around,
searching for the path that matches my footprints.

Work

Poetry by Kelsey Piotrowicz, Senior
Photo by Kayleigh McMichael, Senior

Helios had given us the day.
The green had become imperious,
a fenced in jungle.
I took to the emerald growths with razor sharp teeth, slicing every limb.
The demon he rode ate the ground with deadly precision.
Lilliputian oceans trickled down my face.
The sands of time fell slowly, as the sun remained high in the sky.
The pigments in my skin grew dark, as did his.
The earth left its fighting fingerprints on our clothes.
After finally defeating the olive masses, we bribed Beauty to return.
She and her multiple personalities, Rose, Violet, Daisy, Lilac, Lily, Peony, and Marigold
sat waiting patiently for us to give them the home we promised.
In a bed of nutrients, their summer abodes were dug.
Our muscles were tired, but proud of the fierce victory.
We sat on a swing, to and fro, tasting the lemon zest of summer.
The light in the sky began to fade, as the night tried to steal the remainder of the day.

One Person

Prose by Libby Ennis, Senior

Watercolor by Mitchell Keen, Junior

One person who stands out from my childhood is a lady named Charlene. She is a widow who lives down the road from us. Charlene is a very determined person and always pushes the limit of what she should be doing. Her hair is white, and she has tender, wrinkly skin. She walks a little hunched and with a cane. The house she lives in is very quaint, but the smell of moth balls almost blows you away.

Her family didn't live anywhere close, so she was often by herself. Every Christmas morning though, the first thing my family did was to go and visit Charlene. We would put on our coats and snow boots, then walk over to her house. When we knocked on her door, she would gladly answer it with a grin from ear to ear on her face. As we went into her house, we would follow her into the living room. There we sat and talked for an hour or so, and then she would ask who wanted

hot chocolate and cookies.

We would pull up extra chairs to her little table, just so we all could fit. It was a great time, all of us sitting there talking, laughing, smiling, and, overall, just having a good time. After we finished our cookies and hot chocolate, we would talk for another hour or so. Then came the goodbyes. No one got away without giving her a hug and saying goodbye. When we left, she had that same smile on her face that she had when we arrived. It was plain to see that we had made her day.

This story means a lot to me because time has changed and people have grown up. Now when we visit Charlene, there are only a couple of us that go. It still makes her day to see us though. I don't think Charlene will be here much longer, but I can say very assuredly that she will never be forgotten. She taught me that giving and doing for someone else is way better than getting something for yourself.

The Legend of the

SWAHILI WITCH

Prose by Jake Ayala, Senior
Watercolor by Ariel Rensberger, Junior

We knew it wasn't allowed being there, to be perfectly honest. Some said there were monsters. Some said there was a devil, and some just said it was plain death. That summer, I had moved to Saudi Arabia with my family. I was 10 years old and not at all in a hurry to grow up. I was allowed on every road, except 11th Road. No one went to 11th Road. As I was saying, my brother knew for pure fact that we were not supposed to be there, but that never stopped us.

"This is one of you're worst ideas yet, brother," he told me. My brother Henry was the smarter of us; I was the adventurer. No real problem with that. I had common sense, and that's really all you need.

"Shut your whining, Henry, or she'll hear us." Out of all the legends we heard, the one most told and most believed was of the Swahili Witch. She never left her home, except for when she was a kid, but as far as I heard from the older people, she was clearly crazy then, too.

Earlier that morning I packed a flashlight, a little silver dagger, and a cross for protection from the witch. Henry had a very hard time agreeing to come with me, but in the end he did.

"Where you off to boys?" my mom asked. I was stricken with fear; what should I say?

"To 13th Road, Ma. Science project! Gotta go!"

She looked inquisitively at me. "Are you sure?"

I paused, "Yea, for sure." We turned quickly. Henry nodded at my mom, then ran with me.

"Don't go near 11th Road!" my mom yelled as we scooted out.

We, of course, went to 11th Road. It was cold, dark and scary, but there was one house that was not a complete dump. "Like yellow parchment is her skin; her eyes, as red as the devil's tongue. If she catches you, she will cook you in her big, black, pot. No heart exists in House 1215." That was the rambling of some old British, retired coot. Out of the plethora of stories we heard, there was one constant: 1216 11th Road. I could not believe my eyes; there it was, 1216, the nicest house in the area. "She's using her witchcraft to lure us," my jittery brother remarked.

I was scared stiff. We were there at the house. I was getting goose bumps all over my body. Suddenly, the door blew open, and Henry jumped and ran. I, however, sat frozen and wide eyed. I just remember her looking out the window and feeling her spooky stare. Then in a flash, I turned, slipped, and felt a white hot, searing pain on my scalp. When I woke up, I was looking at the wide white eyes of a beautiful black woman. In the sweetest, softest, voice I've ever heard, she spoke: "You bumped your head there child. Are you feeling okay?" What an accent! It was very thick Jamaican with a hint of British. She, like I said, was the most beautiful woman I've ever seen in my life.

"Where am I?" I was quite curious, because the home I was in was extremely large, but filled with animals, and very dark, save for little patches of light here and there. In the corner there had to be at least one hundred bats, and on the floor below them a puddle of, I'm not so sure how to describe it, light glowing, almost like water. Across from that was a very large tree going up three floors. On it, were the following animals: three toucans, five rainbow parrots, twelve of the scariest snakes I had ever seen, thirteen monkeys, and who knows how many chinchillas. In the sand pit at the root of the tree were twelve very happy turtles.

"You're in the house of Madame Sultiana." With that, a very tall woman in a turban rushed to my side.

"Ma'am?" I called out. She was looking up and down my body.

"Is he coming around? Is he hurt?" she asked the younger beauty.

"No, mama. He is kicking just fine now." All I could think of was how gorgeous she was.

"What happened to me?" I asked in a very thick, hazy voice.

"You slipped and bumped your head child." At her last word, a very small snake slithered in the tree, following a little ball of fuzz.

"What the...?" I exclaimed. A very, very small monkey, about the size of my hand, landed on my chest. He had a very sweet face, black hair that went into a slight point at the top, and tiny hands that held a nut, probably from the tree.

"Is this the house on 11th Road?" I asked.

"Yes, child, and I am Madame Sultiana. Pleased to meet you."

Oh my god, I was in the witch's house. I didn't seem like my mental image of it, though. They were so nice. They made tea in a pot on the stove, and gave me cakes and candies. If I didn't know any better, I'd have said they were saints.

"So why on earth did you disappear for all these years?" She seemed hurt by the question, but answered it anyway.

"Well, you see child, there are good people, and there are bad people. My whole childhood I got made fun of for the color of my skin. I disappeared because I couldn't

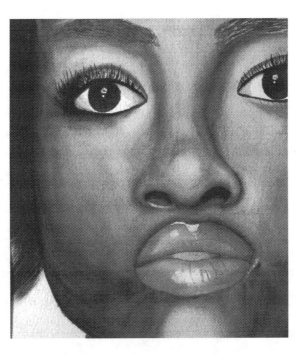

take the ridicule." At this she seemed to tear up, and I felt very horrible. "On my way to school I got stones thrown at me by little boys all the time. It hurt both on the inside and outside."

I was in pain, because I realized I had been a racist at times. I had looked at people differently based on their physical looks; in other words, I had "thrown my own stones at little girls." It was over though. I was done. Once you see the pain on someone's face from horrible memories, you learn to stop the jokes and teasing.

"What was I to do? My only option was to run away and never look back." She sobbed a little. What was I to say? My heart hurt from guilt. All I could do was look down. "Let me tell you something, boy; the choice is yours and no one else's. You are who you choose to be. A very wise man once told me there are two kinds of evil; those who do evil, and those who see evil done and don't do anything to stop it. Remember that."

I left that house later seeing a whole new side of things. There is no black, white, red, or yellow; just people. Over the next three years, we talked and shared each other's stories. We listened to music, and I think I loved her daughter. I've never told anyone about that day until now.

The homeless man who shared with everyone his legend was one of those little boys, I soon found out. One day on my way to school, my mom was walking with me, and Old Judd, that was the British coot's name, decided to share his story. "Like yellow parchment is her skin-." I quickly cut him off.

"I feel sorry for you because that stupid story is all you have to share, and you will never know love." My mother looked at me like I just said twenty different curses.

"Oh, I know who you are! You're that boy who's been living with that nigg-."

I picked up a stone and threw it at his skull as hard as I could. "Not so good on the other side is it, Judd." I got grounded for months, but deep inside I felt good.

Four years later, after my family left Saudi Arabia, I learned a drunk old man burnt down the home. All the animals got out, and the beautiful daughter Kami escaped, all except for Madame Suliana who died saving their lives. I will always remember the lesson I learned from the day I met her. Love is powerful, and nothing like skin color can dominate that, and if it does... you are truly blind to life and all its beauty.

Blue

Poetry by Kaitlin Cassady, Senior
Photo by Kate Smith, Senior

The color of the jeans, most people wear to cover their bottom half.
The color of the ocean that gives the sky its shade.
The color some see through, their world their own shade of blue.
The blue chisel expo marker that marks up a wise teacher's board.
The color of the jacket the little girl wears home to abusive parents.
The tiny blanket wrapped around a parent's bundle of joy announcing a boy.
The color of blood running through her veins before she cuts her wrists.
The shade of eyes I look into as I say, "I love you! Goodnight."
Blue isn't just a color; it describes a lot of stories in life.
What does blue describe for you?

Meanings of Green

Poetry by Jessica Verkler, Senior
Photo by Karen Celmer, Senior

"Green, Part One"

Smell the pine trees as you hang up the decorations,
your nose close to the branches.
Hear the Christmas songs playing throughout the mall
as you hustle to find the perfect gifts for your perfect people.
Taste the delicious fudge, toffee squares or pecan tassies
that your grandma makes every year at this time.
See the lights that decorate the houses
and bring hope on even the darkest nights.
Touch the snow on your windshield, feel an icicle in your hand,
and feel a chill of excitement as you marvel at nature.

"Green, Part Two"

Walking through the forest, you smell the cool, crisp air.
You see the tracks made by small animals and big ones, too,
And when you look up, you see the full night sky,
the stars looking like a salt shaker has been knocked over.
When you walk, you feel surrounded by nature, although you're not sure
what that means exactly...
You look at the trees, and even though you are alone, you get the feeling you aren't.
Something else is there, but you're not sure what.
Stand in a forest sometime, and you will feel it.

"Green, Part Three"

Green.
Such a simple word.
But think of what green is like; you will see it's not so simple.
The early morning, full of unseen beauty, with dew in the grass and the world awakening.
Think of Ireland, with rolling green hills of clover, full of hungry sheep,
or maybe an emerald, dazzling green, in an elegant necklace.
It could be the crashing waves making sea caps on the ocean
or a field full of corn.
A Christmas tree full of twinkling lights.
The Green Bay Packers. Or Green Day.
Green can even be things not seen, like envy.
It is a small word that can give way to a not-so-small imagination.

The Greatest Hits of Kate Jenkins

COLUMBIA

BOB DYLAN
HIGHWAY 61 REVISITED

CL 2389
NONBREAKABLE

SIDE 1

Prose by Kate Jenkins, Senior

Music... Has one word ever meant so much to so many? Music can change people. Music is the key to the most obscure part of the human soul, the part that cannot and will never be unlocked by spoken word. We need music often more than we know and more than we utilize it. The capability of music to make us feel are equaled only by the range of emotions it can create and intensify. Happiness, sadness, depression, love, anger, hatred, rebellion, introspection, retrospection, contemplation, annoyance, passion, and addiction are just a few things I have either heard being sung about or felt myself when listening to music. But happiness, sadness, anger, and love are the most prolific emotions, the ones that are most easily portrayed or evoked by music.

"You make me wanna la la..." ..."La La" by Ashlee Simpson Some music just makes me want to smile, to get up and start jumping around in the middle of class. "La La" by Ashlee Simpson means nothing lyrically, and in fact I can't even understand what she's saying for at least half of the song, but it never fails to make me want to dance. This music is often the pop that plays on a continuous loop of about six or seven songs on the local radio stations, the kind of music that even the most bitter of people, supposedly into "just indie stuff," secretly tolerate and sometimes enjoy. It's Britney Spears, Katy Perry, Kylie Minogue, Gwen Stefani, and Lady Ga Ga. It's those songs in which the lyrics are secondary and often obsolete to the pumping bass and catchy melodies that make people put these songs on repeat. Introspection has no place here; the point of these songs is to simply be, to get up and let go.

"But you've already lost, when you only had barely enough of her... to hang on..."

- The F Words -

..."Dusk and Summer" by Dashboard Confessional

Although some songs make me happy, some can only do the opposite. Whenever I listen to Dashboard Confessional, I can't help but get a heavy feeling in my stomach. It reminds me of the past, of a boy that I trusted too much and the music that he introduced me to. I remember a time when I used to call them my favorite band, and maybe that's still true. But, at least for now, I will leave those CD cases unopened and skip over those certain song titles on my iPod. Soon I will revisit this music without the lingering bitterness and just enjoy it for what it is. All of us are familiar with music like this in our live's; music that reminds us of other times. Whether these times are fond memories or unresolved hurt, past emotions are brought to the present simply by hearing a few notes. This phenomenon has always amazed me, similar to the way a certain smell can evoke memories that otherwise could not have been accessed within the human mind.

<div align="center">******</div>

"Everything you say to me
Takes me one step closer to the edge
And I'm about to break!"
... "One Step Closer" by Linkin Park

You know the feeling: everyone is getting on your nerves, you're sick of adhering to stupid demands from other people, you have no desire to listen to authority, and most of all, you want to be alone. Middle school is a time when most adolescents feel this way on a regular basis, and I was no exception. I started listening to Linkin Park in sixth or seventh grade; they quickly became my favorite band. I remember numerous road trips in which I would sit in the back seat with my headphones on, in the zone. If anyone tried to talk to me, I would give them a dirty look or make a snappy comment, and this usually resulted in me getting yelled at by my parents, but I didn't care. Sometimes when I get angry, I only want to do one thing: listen to angry music, music that not only understands how I feel, but screams it without holding back. If I've learned anything this year, it's that music can help people get through ridiculously stressful and frustrating situations because of this simple fact.

<div align="center">******</div>

"You're really lovely
Underneath it all,
You want to love me.
Underneath it all..."
... "Underneath It All" by No Doubt

No one can talk about music without including the cliche'd but necessary category of love songs. More songs have been written about this emotion than probably any other, and some are exceedingly cheesy. But a few don't bother me; a few seem to actually describe real people in real relationships, namely this song by No Doubt entitled, "Underneath It All." I like this song because it applied to a relationship I was in and seemed to relate to how I felt at the time. In addition, it was understated and discussed a relationship that functioned but was in no way perfect. Many people enjoy those certain unrealistic songs that I find cheesy, which is fine as long as I don't have to listen to them. Who knows, maybe someday those songs won't seem so lame anymore; maybe someday I'll actually listen to Celine Dion instead of making fun of her. But somehow, I don't think that's going to happen. Love, cheesy or not, will continue to be the most popular subject of all music, regardless of what I prefer.

Omi's Perfume

Prose by Nekodah Niedbalski, Senior
Pencil by Mackenzie Hill, Sophomore

You know how when you're younger and everything is more elaborate and seems like it's phenomenal? Like when you haven't seen a movie since you were a young child and remember it being the greatest film ever created; but then you get an opportunity to see it when you're grown, and you speculate why you thought it was such a huge deal? I experienced something like that when I was small, and being a young adult, I still find it extraordinary.

My mom and step-dad both had to work the same shift, so I routinely visited my Omi's house (German for "Grandma"). Though it was small and a single story house, I have more memories of it from my childhood then I will ever experience again. Every room was a treasure of its own. The master bathroom had soft pink carpeting that felt like a

colossal pillow, and the mammoth bath was surrounded by wall to floor mirrors and candles. The kitchen, petite but homey, was always filled with sunlight in the afternoon. Of all the magnificent rooms in Omi's house, I will always favor her bedroom above them all.

Cream colored paint covered the walls, and it matched her king-sized canopy bed with huge side cabinets and an enormous headboard. The stained oak dressers rose against the wall and seemed to gleam as the sunlight poured against them through the windows. Of all the majestic sights beheld in Omi's room, they were not the first thing I noticed. A slight smell of something marvelous wafted in your nostrils. It wasn't too powerful, but strong enough to definitely be noticed. Being a child, curiosity is part of the package, so I snooped around in search of the origin of whatever it was.

Omi had a short dresser catty corner from her bed with a mirror and marble as the "top." There was an amalgam of various perfume bottles and powder cases, but the one thing that caught my eye was a heart shaped container. It appeared to be a type of crystal. Now that I think about it, it was more than likely fake; however, you don't think about things like that when you are young. Carefully, I lifted the lid with great fear that I would break this treasure and peered inside. Before I could notice what was in it, the great scent attacked my olfactory system and did its magic. There it was! The wonderful scent that made me so happy inside. Inside, there were small, milky iridescent balls that I took as pearls. It was truly a treasure.

I asked Omi what it was, and she told me it was a perfume called "Emeraude." She also had it in liquid form in bottles. For some reason, it made me feel happy no matter how sad I was. Every Sunday, Omi would take me to church. I would make the excuse that I had to go to the bathroom while she lightly squirted some on her wrist in front of the mirror right next to where I sat. I loved "Omi's smell." I preferred sleeping with her so the glorious Emeraude could surround me as I slept. Those years were amazing, and I will never forget them.

Years later, as I stood in my black dress and gripped the rose in my hand, I promised myself to never forget her. Though I fought the tears, they forced their way out of me, and there was no place I could gaze but the ground. As the priest made his final prayer and they lowered what once was there, there was a faint, familiar smell in the air. I looked around and knew there was no way any of the various flowers present could produce that scent. I smiled as I continued to cry. I knew it was her way of saying her final goodbye.

Simpler

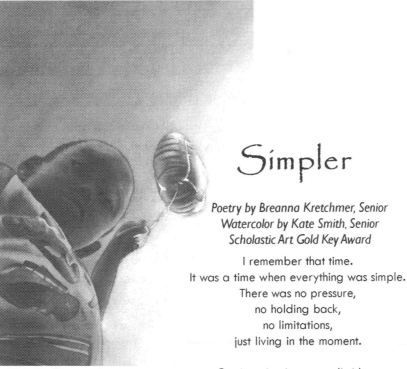

Poetry by Breanna Kretchmer, Senior
Watercolor by Kate Smith, Senior
Scholastic Art Gold Key Award

I remember that time.
It was a time when everything was simple.
There was no pressure,
no holding back,
no limitations,
just living in the moment.

Our imaginations were limitless.
There was no holding back.
It was a time when a little game like snap the whip would bring a smile to your face,
running barefoot in the grass,
the cool breeze blowing on our faces,
just living in the moment.

Squeezing the hand of the kid next to you, trying not to fall down,
it was a time when it didn't matter who was next to you.
It didn't matter if they were popular or not.
You didn't care because it didn't matter.
You were there to just have fun,
just living in the moment.

Things were so much simpler back then.
It was a place where dreams were big,
inhibitions were small,
where you could fly high in the sky
without ever leaving the ground.
You were just living in the moment.

Of Walberts, Poles, & Studebakers

Prose by Ben Walbert, Senior
Photoshop by Kate Smith, Senior

When it comes to storytelling, my father is definitely known as my family's storyteller. To this day, I can remember almost all of his stories. Most of them are of his childhood or his college days. You see, my father is older than most of my friends' parents. So, although I have a father, I also consider my dad as a Grandpa-like figure. My grandfather on my mother's side is always telling me stories of his youth. Since my grandfather on my dad's side is no longer alive, I relate my dad's stories to ones that a grandfather would tell.

Some of my favorite stories of my dad's are those that tell our family history. Most people don't know this, but my name, Walbert, is not my *real* name. My family originates from Warsaw, Poland. From what my dad has told me, my great-great-grandfather's name was Progenitor Wojciechowski. He was born in Warsaw around 1860. His son, my great-grandfather named Wladyslaw Wojciechowski, was born in Warsaw on January 13, 1880. When my great-grandfather came to America, he settled in South Bend, Indiana, with his wife, Eleanor, and changed his name to Waltor Wojciechowski. Most of their relatives, including parents, a brother, and sisters, all stayed in Poland.

My great-grandfather acquired a job working for the original Studebaker brothers' sons in South Bend, Indiana. From the research I've done, I can surmise that he started to work for them around the time they switched from making carriages to making automobiles. One interesting fact is that Studebaker actually favored making electric cars over gasoline cars. That's kind of ironic, because after all of these years, we are just

now going to electric cars when Studebaker originated the idea.

To this day, my family has my grandfather's woodworking tools in our basement. My dad has always told me that my great-grandfather made carriages for Studebaker, but due to the time period that he worked for Studebaker, I guess that he made the wooden car bodies, that were referred to as "carriages without horses." My grandpa, Franciszek Wojciechowski, was born in

1912. I can remember my dad telling me stories when I was younger about my grandfather being a paper boy in South Bend during the early 1920's. My grandfather went by the name of Francis Wojciechowski.

This is where the story gets interesting. When my grandpa was probably in his mid-twenties, he and his brothers decided to change their last name in order to acquire better jobs. At the time, Polish immigrants were not exactly respected. As everyone knows from the joke, "How many Pollocks does it take to screw in a light bulb," Polish people are not considered the brightest. I'm assuming it was this prejudice that kept my grandfather and his brothers from obtaining decent jobs.

When my uncles, grandfather, and my great-uncles came up with a name, they did so in a clever fashion. They took the "W" from my great-grandfather's first name, Wladyslaw. Even though I believe that took it from Wojciechowski, I'll take my dad's word for it. Then they took the name of the church they attended, St. Albert the Great Church, and combined the two. That is how they came up with "Walbert." Some people may think that was dumb, but hey, they were Polish. Evidently it got the job done, because my grandfather and his brothers worked at Studebaker until the day it closed in 1965. After that, my grandfather started to work for Notre Dame in maintenance.

These were only a few of the stories that my father has told me regarding my family's history. There are many other, like for instance, in Poland, if your last name ended in "ski," it meant that at one time in your family's history, a knight with your last name showed bravery in battle and was given the addition to his name. So, in other words, to anyone who has ever looked down on me, I'm from nobility! To top that, even though my family is not sure, we believe that we are distantly related to Stanislaw Wojciechowski, who was the President of Poland after World War I (1922-1926). While that may be just a rumor, that is the wonder and fascination of my father's stories.

CALL of the WILD

Prose by Jacob Marek, Senior

Photo by Kim Lord, Sophomore

Moments that shape who we are hit us unexpectedly. Time slows, and vision becomes crystal clear, as one's entire being is hit by a sudden tidal wave. For a brief moment one is able to see inside one's soul. One realizes what makes true happiness. I have had a few of these experiences, one that I remember in particular.

My moment occurred the summer of my sophomore year in high school. My friend Travis and I were hiking through Shades State Park that summer. Society has never been a favorite of ours. The solitude a wooded region provides is our preference. We, not really caring what we could or couldn't do, hiked into a restricted section of the park. This section was a reserve for animals that were not supposed to be touched by humans. Naturally, this appealed to Travis and I.

Travis and I walked for what seemed like miles. We occasionally would speak, but silence was preferred. The vast silence of the woods was amazing, yet silence was not the word for it. All one had to do was listen. One could hear the heart beat of the surrounding ecosystem. The wind rustled, birds chirped warnings of our presence and squirrels curiously observed from treetops. All of this built up to my moment.

Sugar Creek bends and weaves through the reserve. Upon one such bend, a giant tree had fallen. This giant hung over the creek. Travis and I walked out onto the tree's overhang above the flowing water. Travis sat with his feet dangling over the edge. As I stood behind him, everything slowed down, and I will forever remember that moment. At the crest of the bend was a rock cliff measuring one hundred feet tall. The cliff rose straight into the sky with a smooth surface. It was topped by a few trees coupled with shrubbery. The combination of the silence mixed with the gargle of the flowing creek and the sunset reflecting off the cliff spoke to me. I felt a peacefulness envelop me. It was as if that was what life was supposed to be like. One does not need to win the rat race to be happy in life. One only needs to stop and listen.

Some people watch bees, some fish. I enjoy the woods with my close friends, the ones who also know what it is like to listen.

NIGHT
APPRECIATION

Prose by Dylan Krebs, Senior

This half of the planet has gone to bed. The sky turns over from rolling clouds and infinite blues towards a darkness mapped by the cosmos. Night is a special time of the day, one which escapes us due to our hurried, scheduled lives and our need for sleep. To many this is a forbidden hour, but to a sad, young soul, out in the country this time is precious. Far away from the blinding, twenty-four-seven lights of the city, you take in the massive size of everything out in that darkness. Every sparkle and dot in the sky represents another tiny, precious gem of the galaxy, scattered amongst the immense collection. The cold air blows against your skin, but it doesn't matter once you're captivated by the beauty of space.

Night is like an opened portal. Every creature on Earth can gaze out into the raw, infinite beauty of creation and know that every petty conflict will always be dwarfed by the endless existences that lie beyond our grasp. The portal closes once more as the morning dawns, and we are exposed again on our humble blue sphere. Night takes the heart and mind away on a journey of fantastic wonder and curiosity. We ponder who might be out there, if they're like us, or even if they're watching back. None of these intense feelings and revelations could be possible without night.

Daybreak gives us light to see, but closes our view of the vastness above us, while night time hushes our sunlight to allow us renewal of the mind with every question our brain can consume. Moments such as these make every worry and stress seem just smaller in proportion to the fate of our universe. These moments are breathtaking, offering clarity and inspired thinking. Just like the precious jewels that make up the night sky, every moment such as this is beautiful and should be treasured forever.

Yellow and Green and Blue

Poetry by Megan Snyder, Senior
Watercolor by Catrina Kroeger, Junior
Scholastic Art Silver Key Award

A flowering garden in the spring,
the heady scent of the blooms
perfumes the air around me.
I move past clouds of lilies,
a gorgeous yellow like melted butter,
that matches the iPod that I am plugged in to
and the neon Converse All-Stars on my feet.

 I kick off my Converse
 and run through the verdant green grass.
 I sprint past the broken down walls of the old church,
 crumbling in the depths of the trees,
 vines crawling on spindly leaves over the stones,
 claiming their territory.
 A loud song pumps in my ears and I run faster.
 My best friend is waiting at the beach.

 Bluebells bloom in great patches that
 dance in the summer breeze
 as I make my way to the lake shore.
 The sparkling water shines in my face,
 reminding me of a child's mess of spilled glitter.
 My best friend waits down on the beach,
 a green iPod in her hand
 and green Converse on her feet.

Dancing Time Away

Poetry Renga by Kate Smith, Jessica Verkler, Kristen Whitaker, and Kelsey Piotrowicz
Pencil by Kate Smith, Senior

The first gift that I remember,
A pink tutu on Christmas day,
Dashing through the dining room
In a ballet-slipper sleigh.

How carefree I once was;
How young I used to be.
Now that I've grown older,
So many changes there are to see.

I grow more mature as time flies by.
How I wish those days would return,
To be so young and innocent
And have so much left to learn.

I still dance and prance and sing.
Age can't take that away.
The memories still within me,
Remind me of an earlier day.

FORLORN

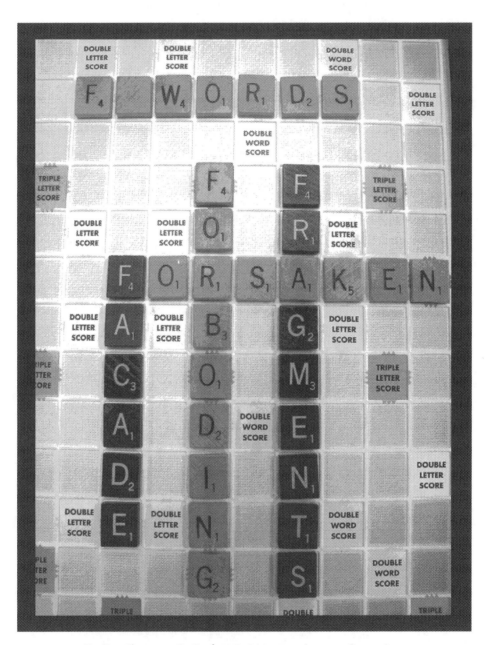

Feeling forgotten? **Forlorn** is just one of many F words
that can fill our minds with loneliness, isolation and depression. Follow our writers and
artists as they focus on fear, fragility, fright and the frozen feeling of being faceless.

- The F Words -

Sorrow Moon

Poetry Renga by Kate Smith, Kristin Whitaker,
Kelsey Piotrowicz, and Kate Smith
Oil by Brooke Poeppel, Senior

Moon, imprisoned by the clouds,
Your cold teardrops are ice on my skin.
I'll soak in your distress
To hide my own.

Pain, hidden in my heart,
It aches to remember all that way lost.
I feel the sorrow
That grips each of our lonely hearts.

Cold, touching the empty night,
I reach for you and find an empty space.
Ask me to miss you,
And I may hold myself together.

Chill, saturating my shivering soul,
The ice freezes my hopeless thoughts.
I look up and think back to your sorrow,
Moon,
Unappreciated and disregarded.

Waiting

Poetry Renga by Kelsey Piotrowicz, Breanna
Kretchmer, Kristin Whitaker, and Megan Beery

A frozen window in time surrounded
by the blazing lives of others yet
numbed by the frigidity that encloses me.
Waiting, waiting
For the chance to come
to break these chains that trap me
here in frozen solitude.
Waiting and wishing for
a passerby to burn through,
to cremate these walls of isolation.
But for now I am at bay,
waiting, and forever hoping that
an angel will see me shivering.
My heart has grown so cold,
desiring a fire to begin from within.

Half and Half

Prose by Colten deFluiter, Senior

Charcoal by Kate Smith, Senior
Scholastic Art Silver Key Award

Most people who we meet in our life have two sides to them: the side they show the world and the side they try to keep hidden. They put on a face that they think the world will approve of and push down the side of them that they are ashamed of. The real question is what side is the real you?

There are all sorts of things that can rip a person into two or more separate personalities. So people have a clean and dirty side, or a gay and straight side; Kate Malone in the novel Catalyst describes herself as good Kate and bad Kate. I often divide myself into Smart Colten and Dumb Colten.

Smart Colten (SC) is the kid in class who is always raising his hand to answer the teacher's questions. Dumb Colten (DC) is the kid who is sweating bullets when the teacher says we are going to take turns reading aloud. This is one of DC's greatest fears. He will try to read ahead to see what paragraph he will read, but he always ends up looking like a fool. In English, DC will struggle through the first chapters in a novel, but luckily, SC can gather enough information from those handful of pages to pass the test and talk about it in class. In science class when we do current events, DC is the student who can't read aloud the paper he just typed, but SC can get up in front of the whole class and give a ten minute verbal presentation

about a documentary he watched a week ago and take questions over the subject.

There are classes that SC refuses to attend and only DC is present. In math class SC takes a nap for an hour, and DC gets to struggle through a period of algebraic hell. It is not that SC doesn't want to help DC, it's just that when it comes to numbers, SC is just as bad as DC. It is best for SC to take a break and let DC take the blow to his ego, because he is used to it. SC is the kid receiving an award for his academic achievements, and DC is the kid who is scared to fill out the form for the recognition dinner because he knows he will spell something wrong.

Even right now, as I'm writing this, there is a struggle between DC and SC. SC can think of whole story lines in his head and describe them with a plethora of beautiful words, but when DC tries to write these words for SC, he often can't even spell the words close enough for spell check to know what the hell he is talking about.

The battle between SC and DC made me what I am today. SC is what gives me my spirit of discovery and thirst for new knowledge. DC gives me a view of the world from the bottom up, my perseverance and empathy for others. Without DC, SC would become AC (average Colton), and I would rather be half smart and half dumb then one hundred percent average.

Neutral

Poetry by Cody Phillips, Sophomore
Photo by Karen Celmer, Senior

I am on neither side,
the good nor the bad,
the right nor the wrong,
the white nor the black.
Purgatory am I, neutral in this life.
I am the divide between dark and light.
No hate and no love, none of the above,
I look to the stars when times get rough.
I am looked down upon for not choosing
a side by the demons of darkness and angels of light.
I walk a path of equality
although I'm pressured day by day.
I am surrounded by fallacies,
but I don't let them change my uncolored ways.

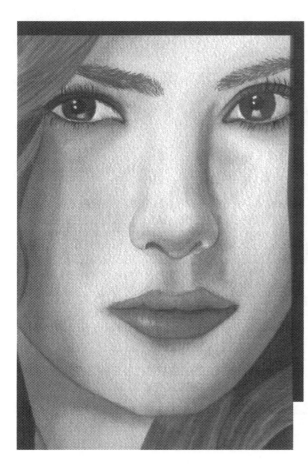

Deceiving Eyes

Poetry by Chantell Cooper, Sophomore
Watercolor by Catrina Kroeger, Junior

So happy and joyous
Or so you think.
Staring into my eyes you see
What I appear to be,
A simple, joyous girl,
The perfect life,
But these deceiving eyes have fooled you,
Fooled you time and time again.
A perfected mask,
The unbreakable mask,
It's become part of who I am,
Or so I try to convince myself.
Every night I take it and lay it gently on the desk
Below the bright lamp
Shining on the mask yet again,
So bright, so unbearably enticing.
Somewhere along the way
I lost myself.
Somewhere I lost my soul deep within the mask.
As it stares back at me, I realize I've changed;
I'm no longer who I once was.
I'm what this mask has made of me,
What these deceiving eyes will never let on.
They will never show you what I buried long ago,
What I let die long before you ever knew.
These deceiving eyes
Will never let you see what lies behind them,
Forever considering me what the mask has created
Never knowing the me screaming inside.
The me I want so badly to let out
Will never show
For these deceiving eyes have fooled you yet again.

Restless Like Him

Poetry by Lauren Kipper, Senior
Scholastic Writing Certificate of Merit
Charcoal by Ashley Navilliat, Senior
Scholastic Art Silver Key Award

Have you ever felt the restlessness in your legs
That wants to carry you away,
Restlessness that overtakes?
Have you ever felt the restlessness in your legs like him?

He comes and goes carried by the restlessness in his legs,
Blowing into town and then blowing out again with the seasons,
Never staying but always going.
He always asks me, "Do you feel the restlessness in your legs?"

I have never felt this restlessness that fills his legs.
I feel a need for home,
A want that keeps me stationary.
I always wonder, "Do other people feel the restlessness in their legs?"

An acquaintance said, "I only feel the restlessness in my legs during the winter
When the cold winds blow and the snow starts to fall."
Warm places sound so sweet but yet the acquaintance stays.
The acquaintance always ponders, "Do my children feel the restlessness in their legs?"

The children feel this restlessness in their legs during the school day.
Studies and learning bore them.
How they wish to be outside playing and running.
The children always wonder, "Does my teacher feel the same restlessness in her legs?"

Ms. Teacher feels this restlessness and is just looking for a way to escape this feeling.
She wishes and waits day after day,
Then finally she meets that man with the restless legs.
He asks Ms. Teacher, "Do you feel the restlessness in your legs?"

Ms. Teacher and the man with the restless legs don't feel the restlessness anymore.
They smile and wave at the young couples strolling pass their front porch.
The teacher and the man are happy and content,
Yet they always ponder, "Does that young couple feel the restlessness in their legs?"

thepoliticsof
Cool

Prose by Nekodah
Niedbalski, Senior

Tempera by
Mackenzie Hill,
Sophomore

Have you ever been pressured to be someone that you are not? Or have various individuals continuously told you that you should change? Watching the rain pour on the pavement next to my house causes me to reminisce of a time when I wished to be accepted...even if it meant to change.

Elementary school seemed like a cakewalk; after all, you only learn your ABC's and 1,2,3's, but my experience was much more than that. I sought for social acceptance by everyone, being an enormous people pleaser. For some reason, not that many people cared for me. It made no sense. I was pleasant to everyone and shared like I was told by my teachers, but little kids gossiped and made fun of me.

Finally, I came to the conclusion that action had to be made by any means necessary. I asked a group of popular girls what I could do to be "cool." They studied me from head to toe and with an array of snickers surrounding me. They told me that I should dress more like a girl than a boy. As soon as I got home, I pleaded with my mom to take me to a J.C. Penny's so I could buy dresses. My mom was thrilled, of course, since I am the only daughter, and now I wanted to dress "girly."

At school the next day I wore a pink dress with lacy socks and dress shoes. My hair was in tidy braids with my face scrubbed clean. Perhaps now you think I was happy? I was actually the opposite! The dress was uncomfortable, and I felt revealed. The socks itched my legs, and the shoes blistered my little feet. It wouldn't matter though, now that people would like me.

Rain poured on the ceiling during class, and everyone whined with disgust. I was the only one smiling and proclaimed that I loved rain showers. A girl from across the room stated that I was weird and things like that were the reasons that people didn't like me. After that, I stayed mostly quiet. It seemed that all the quiet girls were liked,

so I changed my outgoing personality for everyone else.

Some girls told me that I was becoming more "cool," but I still needed to change. I was told not to hang out with my best friend at the time since he was a so-called "loser." From then on I ignored him without telling him why, all for acceptance. I kept asking the same group of girls what I could do to make myself even more likable. No more video games or listening to 80's music and opera. They were the things I cherished so dearly but had to part with in order to be accepted. I gained fake company, but not what I would label as friends. Sure, I was in the "in" group, but it wasn't who I was or how I wanted to be.

One day my best friend came to school crying because his dog had passed away. Sympathy swept over me. I picked up the edges of my frilly dress and ran to him. As I sat on my knees, ruining my dress on the black top, I held him and told him that I was always here for him. The group of popular girls stood over us and stared viciously. I was told that it was either my best friend or them.

At my aunt's garage sale, a brown box sat by the stoop. An old lady told me that her granddaughter would love these dresses, and she purchased them. I stood by the cash register with my aunt, my hair disheveled, and dressed in baggy jeans and

a Jimi Hendrix shirt. My best friend helped me put all the stuff outside in the garage sale since a thunderstorm was approaching. As it poured on the pavement, I realized that gaining acceptance is trivial. If people can't like me for who I am, then it's their own problem. Many people don't like rain because it's "dreary" and different, but people fail to understand that rain brings life and beauty of its own, just like people. While everyone complains about the rain, I'll still be the one smiling with joy.

Grey

Poetry by Kate Smith, Senior
Marker by Ashley Navilliat, Senior

The ice air makes you fall and break

And turns you cold blue as you bruise,

As shaggy branches swing

Into your path.

The clouds knot in the sky,

Roll in and groan,

Stretching their muscles then strike,

Shoving the casual airy night

To the side,

Sending bats flying wild from their cave,

Things that take color out of life.

When the Reel Runs Out

Poetry by Kate Smith, Senior
Pencil by Kate Smith, Senior

You're lying, static, on the floor.

I feel a chill seeping into my skin,

Not because it's December.

The scene slowly fades to black and white.

Motions are played out piece by piece

Like the reel of an old film,

Spots on the side, scratches on the screen.

There's bright light all around.

Your angels are coming, aren't they?

Yes, your angels are here.

You go on; take those steps two at a time.

Go on, into the clouds, into the stars;

Don't worry about us.

I'll wish you one more goodbye,

Silent but sincere.

Now go.

The film, the grain,

It all falls to pieces.

The reel reaches its end,

And the picture falls apart.

Light In The Dark

Poetry by Megan Beery, Junior
Watercolor by Seth Baker, Junior

When I got up this morning, all I could say
was thank you for another day.
Even though I wanted to roll over
and sleep again, somehow I ended up here
where everyone looks at one another with a leer.
They grin and giggle, while I write poetry
going to where I hope you need me to be.
I seriously try not to flee
because their moods and fashions change
almost as often as they say my name,
Which is fairly often, you see,
for they seem to see something in me
that just isn't there,
and in the end it leaves me feeling bare,
like I'm just as fake as them
as they race around, pretending to be men.
But they're all still children
because so easily they loose sight of me;
every time another pretty face goes by
I seem to disappear,
all because more of her is bare,
more than modesty would choose to show,
too easily does she let it go.
I'm more than this though,
and I try to let that show
because your love is so much more
than any love that they could have in store,
or whatever the darkness promises,
because so easily the lies wear thin,
but by then, I've already given in.
This sin, it's taking over, forcing me to
hover in guilt and regret
until finally I am met
by the grace that washes over,
leaving me feeling loved and at peace.
All too soon temptation does return,
causing me to want to burn
all the bridges I built between
myself and the unseen.
How could I be so stupid?
Punishment must descend,
and so once again I'll pretend

- The F Words -

that I feel okay.
I smile, just to make the people go away.
Then your love comes again.
I am truly happy as your fire
burns within me, and though
they call me a liar,
the truth of your love, I can't contain.
I feel whole every time I speak your name.
"Angel" they call to me as I walk through the hall
or with them in dark stores at the mall.
I stay pure as they party, as they get wasted; I pray
that I'll get to be with them just one more day
and that they'll listen when I speak your name.
Because you sent friends to love
me when I felt so alone,
now I want to show your love to them,
so that someday they'll be men,
strong in your word, and girls without
regret, following your will
rather than one night of happiness,
and have them find delight in your bliss.
So while I now walk in the dark,
it's your light that leads me and teaches
me your will.

ROAD Kill

Prose by Nicole Noland, Senior
Watercolor by Kate Smith, Senior

There's just something about hitting an animal with a car that makes me sick to my stomach. That fear rivals my less than stellar driving skills in the "Times yelled at by Driver's Ed. teachers, parents, and other passengers in my tiny Saturn S R T " department. I'll do almost anything to avoid hitting a squirrel, rabbit, or, even worse, someone's pet. It's not that I'm worried that hitting a deer at 55 mph with the headlights on and the horn blaring will dent my car beyond repair, or that I really don't feel like telling someone that I just ran over the family dog. Sure, that's part of it, but it's more of a personal fluke. Something strange and random that happens to really bother me more than it should. I'm scared for life, you could say. All because I watched a little baby squirrel die on the yellow median line of State Road 23.

The entire story has to begin inside my car. Picture me speeding down the highway, windows rolled down, with me in my STYLISH yellow and plaid sunglasses, screeching the lyrics to the Fall Out Boy song I had blaring through my speakers. Horus (my precious, golden-colored little car) was acting nicely for once and running quite smoothly. Bonus. All in all, that day was not too shabby of a day. But as I braked slightly (too slightly for my mother's taste, I might add) to turn onto my road, I saw something lying in the middle of the highway. It was a squirrel. Now, I've seen road kill before. Who hasn't? All squished up and nasty, with cars swerving around it, careful not to get a chunk of intestines on their SUV. But this little guy...he was still alive. Someone hit him, and he didn't die right away. He was flopping around, half his organs lying a foot away from him. I clapped my hand over my mouth and had to look away. It bothered me. I'd never seen something die before. I slowly took the turn to my house and pulled into the driveway. I couldn't stop thinking about that little squirrel. My brother would have told me to run it over again. A "mercy killing," he'd call it. I can tell you, I'll never be able to do that.

- The F Words -

To feel the bump in the car as I'm driving over an animal's body, knowing that I'm killing it...I can't do it. I'm terrified of spiders, but I still refuse to squish them. I capture flies and release them through my window. I can't kill anything. I can't take life away from something, be it an insect or a person.

That squirrel meant something to me. He was in the worst pain that he would ever feel and seconds away from death. Yet the world went on. Nothing changed. Maybe that's how we are with each other. We'll all die someday. Some of us in tragic accidents, taken too soon. Disease will claim more of us. Murder. Suicide. Old age. Regardless, there's not a single person living who will stay that way forever. When our day comes, who will care? Sure, there will be a few people who will mourn and grieve, but the world will go on. Nothing will change.

When that baby squirrel finally died, there was no moment of silence. Cars kept driving too fast; my stereo kept playing. He was gone. All that was left was for some pickup to plow over what was left of him and spread him into three different locations.

It's a painful thing to realize that you don't matter all that much in the big scheme of things. Accepting that Earth won't crash and burn when you cease to exist helps a little. I try to think of it this way: everyone I know and love will be nothing but dust and ashes in 100 years, and so

will I. At least try to make the most of the time you have.

Nobody

Poetry by Kate Smith, Senior
Scholastic Writing Gold Key Award
Photo by Kate Smith, Senior

She sits. I can feel her eyes on me.
I am Nobody.
I am her only company.
She looks around and we gaze at each other, though she does not know it.
I can see her questions behind those honey eyes.
I can see her determination to avoid me.

She tells herself he will be here,
That in fact, somebody is coming,
And Nobody's not already there,
But I am.

I'm sorry, dear girl, you do look lovely,
But he's not going to show.
You sit on this porch waiting, in your white lace and skirt,
With your hair straight and makeup flawless,
But he's still not going to come.

I waited as long as I could before coming.
I didn't want to get you down when you were so excited,
Because I know my presence is deadly.
But it's time to go inside Dear.
You can only look down the road so many times
Before the tears start to fall.
I never wanted to make you cry.

So go inside.
I promise you, once Nobody's here, there's nobody coming.
You, with your pretty outfit and jewelry,
Please stop searing me with your stare.
He's not coming today,
You're in Nobody's care.

The Clock Is Ticking

Poetry by Janay Crane, Freshman
Oil by Chris Wenger, Senior

It just turned 12:03
and it isn't that hard to believe
I've been staring at this clock for
what seems like days
My life is just going by
in a haze, I can't see the end
There's no light around this bend
only black emptiness
I feel like I've fallen, how crazy is this

And the clock is ticking
and the sand is sticking
and I've got nowhere to run
I'm looking around
searching for the sun
and I can't find it
It disappears
and with this
dark, comes my fears

I've fallen asleep at my desk
I guess I needed the rest
I get up and turn on the light
expecting it to be bright
but all I find is dark space
There isn't a light in this place

And the clock is ticking
and I'll keep on sinking, sinking
I've got nowhere to go
nowhere to hide and I feel
all cold inside I'm searching for
something, never to be found
I'm reaching for it, but it's
too far off the ground

What have I gotten myself into
What have I done
Now I'm sitting here
and I will never see the sun
and I guess my nightmare has only begun

The Rules and Regulations of Pop Culture

Poetry by Chloe Jacobson, Junior
Charcoal by Michelle Seely, Junior

To be stuck in the same
not able to move on.
To dream a thousand dreams
and have none of them come true.
To wish upon a star,
only to have it fall to the ground.
To hope for change
and still live the same.
To see the world crumble
at the hands of the corrupt.
To watch an era fall and never rise up.
To remember when it was good
and when equality reigned over all,
to the time that is now when only
the good fall.
To rise up and act
and greet the abstract,
the untouchable, the invincible
the concrete world that is our home.
We don't fix what is not broken.
We don't confront the problems
that don't hit us first.
We segregate, we compensate,
our differences are what make us one.
One in the same.
One future.
One life.
One whole.

IRRITATION

I love to irritate people. It's a hobby of mine. I list it under "Activities I Enjoy" on Facebook (add me as a friend, "Nicole Jenniffer"). It's enjoyable and a great way to stay in shape. However, I'm a veteran at the art of irritating. I don't screw with the trivial, shrill-voiced shriekings of freshman girls who cause only a mild annoyance. Oh no. I throw my whole into it. It's the easiest thing in the world because it takes no real effort on my part. See, when I irritate, it's not even on purpose.

Here's my secret: high school is, by definition, where people group together. Of course, we have John Hughes as a scapegoat, seeing how he rekindled the Name Game in the late 80s (*Cough, Breakfast Club, Cough*). There are the classic "Jocks," "Nerds," "Cheerleaders," and the ever-popular "Girls Who Eat Their Feelings." Now, it's an unwritten rule that from the ages of 14 to 18, one must mold him or herself to fit into a group. Conformity makes the world go 'round. But when this delicate social web is disrupted, people tend to become disgruntled. You don't quite fit into any group, and Bingo, you become irritating. Irritating for not being able to be boxed. "Is she Emo? No...maybe she's Preppy? How can you go from Emo to Prep?" It's fantastic to sit back and observe them scratching their heads, finally write you off as "Weird," and go about their business. See, it irritates people when they don't know what to call you except by name.

I tend to irritate people because originality is a lost art. People are concerned with mass acceptance and forget they have a mind of their own. Just being Nicole isn't enough. I'm expected to be Emo Nicole, or Artistic Nicole, or Geeky Nicole. Honestly, that bores me. I've made it my life's mission to stay original. I believe in originality like I believe in Barack Obama, because

honestly, who defines normal? Normal changes with culture. It's constantly changing. You can't keep up with it if you try. Believe me, people do try. I've never understood this because, logically, normal is pretty much useless.

So here's my challenge to you: irritate. Irritate as much as you can and be a wonderful, beautiful original. Don't die after living like a million other people. Wear eye shadow like a rainbow. Paint your nails with White Out. Do whatever you feel like doing and don't give a crap if it goes with your image. Understand that you'll be a minority. You'll be one of 6.7 billion. That's a lonely number, but here's how I look at it: It's 6.7 billion times better to die without a title than to live someone else's life. Die with your name and nothing attached. Develop a serious allergy to boxes. Learn to take people's grief. But never let them take you alive.

Prose by Nicole Noland, Senior

Charcoal by Robbie Welsh, Sophomore

Remember Me

Poetry by Ayla Felix, Junior

Photo by Kim Lord, Junior

When I'm gone
And it's only you left here,
Will you remember me?
After everyone else is gone
And you're all alone,
Will you stand at my grave with roses?
When you're old and gray
And your children are grown,
About me, what will you say?
The memories you have of me,
They are my legacy.
So, I ask you,
How will you remember me?

Empty Picture

Poetry by Janay Crane, Freshman

Oil by Chloe Bugajski, Senior

I was walking around one day with
the world on my shoulders.
All I could see were tears.
All of a sudden everything seemed to get colder;
the wind blew in my face and there were leaves all around.
Then I found something lying on the ground.

It was a picture with nobody in it,
but there was something on the back.
It said,
"We were invisible just like you,
we were never seen
and we suffered, too.
We just faded anyway
and no one will ever remember,
so burn this picture with fire's embers."

Ever since that day I kept that photo
just to remind me how far a person could go.
If people never saw you, if nobody cared
and no one will,
that knowledge is enough to kill.

Because I'm invisible just like you,
I am never seen and I suffer, too.
Now no one will remember me,
and that's how it's going to stay,
an empty picture with nothing to say.

eve

Fiction by Kate Smith, Senior

I'm wearing a velvety red, floor length dress; it's got a slit up to the middle of my thigh, and my heels give me the feeling that I could own anyone in the world. My makeup is flawless, and my best friend is gleaming in her splendor. The crowd is looking at me with the highest expectations. I'm Eve. I'm twenty-six years old, and I work with my best friend, my glossy black piano, at the Atlantic Breeze. It's a classy evening club in the heart of Boston. I work five nights a week, and it's the best job I could ask for. I work for a man named Martin. He's a down-to-earth realist who gets involved in his club. He hangs around almost every night, helping at the bar or letting guest bands in extra early to set up.

Even though the people I play for like to think they're my biggest fans, they're not the only ones in my life who are there for my every step. The idol of my life is Tyler Blake. Tyler... He oversees construction for a company that does a lot of work for the universities around Boston and Massachusetts. We met at a friend's birthday party four years ago, and we've been engaged for four months. I am going to marry the greatest guy in the world, and I still can't get over it. He lives in an apartment six blocks away. He's twenty-seven years young, and he makes me feel alive. His sandy brown hair always smells like wood chips from work, and I love it. It's a homey, hard working kind of smell. When we're together, we usually end up roaming the parks to walk my cockapoo, Bug, curling up on the couch with the TV, or hanging out at dinner with his friends or mine.

Most of the people at the Atlantic Breeze are friends. Two nights a week we go out in a group and head to Marnie's, a local bar that mostly fills up with after-hours workers. The group usually consists of Rocky and Teagan, our bartenders; Milla, Scotty, Derek, and Sarah, the regular musicians I play with when there's no guest band; and Paxton, one of our managers.

The music's closing down, and I end my piece. The audience is clapping. We appreciate the love and start up with a catchy dance beat. Our regular dancers get up and head to the floor in front of us. Everyone, I mean *everyone* has a good time here. Martin's heading over to dance with Mrs. Heally, a regular elderly woman

who gets herself here every Thursday night. My piano is bursting with sound, holding rhythm and coming to life all at once. This gorgeous dress is wrapped around my legs, and my heels are dancing with the pedals. I can feel my earrings sparkle in the spotlight, and my hands are doing their own dance on the keyboard. These are the nights I live for.

Eventually, the night ends, and we all pack up to leave. I turn into a normal, young woman in Boston. I chat with the other people cleaning up or putting away instruments, and then head out to walk to my car. It's twelve-thirty and a gorgeous, starry night. College kids are roaming around the Boston Common Park, and a few are walking hand in hand. I reach my blue Mercedes and start the drive further up the city to my apartment, where I shower and slip into some light pjs. After a quick pasta fix, Bug curls up beside me in the bed, and I flip on the TV to watch Leno.

Tyler calls me at quarter past one, and we talk for about a half hour. He really is the biggest sweetheart. On days we spend together, he's forever trying to think of something I would be interested in, and he spends the whole time doting on me. It's not that I ask for it, it's not that I demand it; it's just the way he is. When he proposed, it was like my life clicked together. We were in Boston Commons at seven at night, so the sun was going down. He was wearing a dark blue button up and khakis; he looked like a model. We sat by the fountain and ended up having a bit of a splashing fight that ended with a makeup kiss. After talking about life for awhile, he led me into the rose garden alongside the park and sat me down on the edge of that fountain. When he didn't sit down next to me, I started to get that tingly feeling, the one where you can't feel yourself breathing but you know you must be, because you're still alive. You forget to blink your eyes. You try to keep a smile off your face because you don't want to look like an idiot, when you don't even know for sure what's going to happen. My breath was caught in my throat when he started to kneel down beside me. At the moment his knee hit the ground, the twinkling lights that were strung through the bushes all lit up. A tear slipped out of my eye as I drifted into the beautiful dream. I didn't think about it until later that those lights are always timed for eight o'clock. I guess I wasn't thinking too clearly.

So now I'm on my way to being Mrs. Tyler Blake, and like I said, everything is falling into place. We've already found our future home right

Colored Pencil by Nekodah Niedbalksi, Senior

outside the city; it's an old Victorian charmer. We plan on having a family a few years down the road. We're waiting until he finishes his degree in construction and gets the promotion his boss is promising when the current Management Overseer retires in a year. It'll be Tyler and Eve Blake, a two story house with a white fence, a sedan and a red truck, and a dog named Bug. We'll have to get a sign that says "Kids in Future" so we don't have to hear about how the only thing missing is a colorful bike in the yard.

My life could go on like this forever, and I would never complain.

<div align="center">***</div>

"Cash or credit?"

"Look like I got credit?" the woman snaps. I get this all the time. *Look lady, I'm just doing my job. I don't have time for this. I need to go clean up aisle six. Someone knocked over a display of canned soup, and some didn't make it. Get off my back. My boss is going to have my ass if I don't take care of that. Not like she's going to get up and do it, not when she's busy betting on one of the computers in the back. So really, get your crap and get out of here. Please.*

The woman pays and I flip the sign up saying my register's closed. While I get the mop ready, one of the guys who works here checks me out. It grosses me out. You'd think by now I'd be used to it, but it still chills me when I can see someone scamming on me and he doesn't even try to hide it. Especially guys like this. Especially when I'm alone.

I get the mop and water and get the hell out of the stock room. I clean up the soup. Eventually, after hours of the crap this place gives me, I start walking home. Well, it's a house that's not a home. It's more like a shack, and it's disgusting. It smells like rotting garbage, beer, and cigarette butts from all the neighbors. Me, too, I guess. Somehow I went from the top floor apartment on Fellows Avenue with an amazing job, a Mercedes, and a boyfriend to this. To the basement of a crap apartment building with no car, no dog, no man, and a job at a register in a low end grocery store.

Don't ask me why I'm here. I ask myself every day.

<div align="center">***</div>

The phone rings. Bug jumps out of bed at the sound; she hates being bothered when she sleeps. I look at the clock, and it's three thirty, a.m.. It's three thirty a.m.. I can't think of anyone who would be calling me. Then, I remember that Tyler's out with his buddies. One of them is getting married and tonight's the bachelor party. It must be him, even though I have no idea what for.

"Hello?" My voice cracks with sleep.

"Hello, is this Eve Marsh?" a strong male voice says in a tone that scares me.

"Yes, this is. Who's calling?"

"Ma'am, my name is Wade Braughn. I'm an EMS attendant. We have Tyler Blake with us. You're listed as the person to contact in an emergency..."

"What? Oh God, what's going on?" I'm awake now. I'm getting out of bed and yanking a T shirt on. I don't even realize it's his. It's his favorite, a shirt from his first years of college. "What's going on? Is he okay? Please tell me he's okay."

"Miss Marsh, Mr. Blake has just been transported to the Boston Daily's Hospital. He's been taken into the emergency room. We need you to come right away. He's in critical condition.

"Is he- what happened- how did..." I'm rambling on with questions flooding into my head; I'm bolting down the stairs. I can't wait for the elevator. "I'll be there in fifteen minutes. Thank you very much, sir."

"Yes, ma'am. I'm sorry you had to get this call. I wish him the best of luck."

"Thank you." I'm already running down the street to the parking garage. I toss my purse into the passenger seat as soon as the door opens.

I get to the hospital and sign papers. I fill out forms. I hear someone breakdown when she gets the news that her mother has died. Oh God, that can't happen to him. Tyler can't die. He's twenty-seven, right? No one around here will tell me what's going on, and I'm on the verge of insanity. Finally a doctor comes out and tells me something. He's still in critical condition, in a shock-induced coma. They let me see him for all of forty seconds with nurses and doctors still flying around us.

"Tyler, babe, it's me….. It's me…. Can you hear me? It's Eve. Oh, God, please, please, wake up Tyler.

- The F Words -

Photo by Chloe Bugajski, Senior

Wake up! This can't happen. I love you, please, I love you so much! You can make it through this! Wake up!" I'm losing it. There are tears streaming down my face. His head is wrapped in a bandage. I can only see one eye. His whole left side looks like it got crushed, and his legs are charred... He was in a fire. Oh God, what happened?? He's hooked up to a breathing machine, and there's a bag of blood being pumped into his arm. The nurses around me are speaking in a language I don't understand, things about blood pressure, heart rate, pulse, whatever it is they're trying to control. I hear something about irregular heart rate and respiratory shock. I grip his free hand and clench it to my heart.

"Tyler, Tyler, you need to wake up! Please, wake up! God, this can't happen!" A doctor tells me he'd like to talk to me outside the room. There's nothing I can do, and I can't stand to see him like this anymore.

Once we're outside the room, he leads me down a hallway. We talk at the end. I find out he was still the only sober one, driving his other buddies back to where they were staying. They were hit by a man who's BAC was .19. I didn't think people could figure out how to turn a car on, let alone drive that drunk. He and his friends were hit head-on on a highway coming back into the city. The best man died at the scene. The other three are in critical condition, too. Tyler's friend Mathew was air lifted to a burn center further away. The gas tank exploded. Tyler wound up stuck. They all wound up stuck. They all burned.... Oh God. His heart can't hold a steady beat. One lung collapsed. Half his body was crushed when the guy ran into him...

All these thoughts are swirling through my head; it's impossible for me to think clearly.

He can't die. He can't die. He can't die.

"He can't die." It slips out like a whisper; I didn't even mean to say it.

The doctor looks at me sympathetically, and offers his hope. He says they're taking him into emergency reconstructive surgery for his lungs and heart. He'll find me as soon as they know what's going on.

<p style="text-align:center">*</p>

Tyler's dead. He died on the table. The doctor tells me, and I collapse. This can't be happening.

"He's twenty-seven!" I shout. Like that can make a difference. Like this can only happen to someone who's sixteen, or thirty-nine or fifty. Just not twenty-seven. Just not him. Just not Tyler. Not Tyler. Not him. Not the sober driver when he should have been enjoying his night anyways. Tyler's dead. Oh God. What do I do?

<p style="text-align:center">***</p>

My life spiraled out of control.

I started slacking at work. After getting a month off, I thought I was ready to get back into it. I wasn't. Some nights I could pull off the act, but it started to turn into sloppy hair and a plastic smile. The regulars knew, and I could see that they could tell. I didn't get the same cheers I used to. They were still nice; they were still supportive, but I could see the pity in their eyes. When guest bands would come in and I'd be playing piano for them, sometimes I'd get invited to parties. Parties I never used to go to. I didn't even know those people. I still

don't know those people.

I tried some drugs at these parties. It started out with drinking with them. Then when I got tired of drinking, when I saw the effect these people were getting from this mess of other drugs they used, I took a dive. I didn't even go slowly, starting with easy stuff like marijuana. I started with Ecstasy. Then I tried some other pills. I hardly considered pot a drug, but it eventually became a regular thing to just help take away the smothering feeling I lived in. It helped me not care quite as much. But only a little. So I wanted more. Three months after these parties week in and week out, I was done for. It eventually got the point where I was going home with strangers. That's how screwed up I got. That's how fast.

Most of the people handled themselves better than I did, but I'd never been into that kind of stuff before and was suddenly romanticizing the escape of it, the window it offered. What no one ever told me was that the window was on the top floor of a New York skyscraper. I fell, and I fell fast.

Eventually, I lost my job. Martin tried talking to me a couple of times; he knew, and the other musicians I worked with knew. Everyone knew. Eventually, I started missing work. God knows where I was. One day Martin took me aside, and we talked. In the end we agreed I couldn't keep working there in the state I was in. I'd lost weight, and starting out at 130 pounds, people noticed when I started dropping. I'd only lost about twenty pounds by the time I left Atlantic Breeze, but when you're 5'7," people can see that kind of thing. My cheeks were shallow. I had bags under my eyes. My hair was greasy. My clothes got dirty and never got washed. My smile ran away.

I lost my apartment after that because I couldn't keep up with the rent. I gave Bug to my niece who lives about an hour outside of Boston. My car…. I crashed my car one night driving back to my shack after picking up some stock. This was only a couple weeks after I started into it. Into the big one. Heroin is what got me. It's what I got stuck on. It's what I live by. My dealer let me hang out at his place to try this new line, to see if I'd want that from then on. The drive home… It wasn't a good idea.

You might say it makes me exactly like the man that killed Tyler… But I don't think about him anymore. There's nothing I can do, and the guilt trip I get thinking about him just pushes me to do more. Tyler's gone. Mrs. Eve Blake is gone.

I picture this all the time. What would happen if I introduced myself the way I really was.

"Hi. I'm Eve. I live in a basement and shoot up. How did I get here? I try not to remember."

I can't do that….. those are things you just don't say. But I'm tired of people looking at me and having those thoughts run through their head anyways. I'm tired of seeing people check out my hair and my eyes, and see the clothes I wear, and eventually, their glares make it to my arms. I've got tracks up the one side. It's disgusting.

Everyone in my neighborhood is kind of like me. Okay, not everyone. But a lot of people. There are actually some good people around here, but they stick to themselves. I don't blame them. My apartment, on the other hand, is full of people you try to stay away from. I'm not even talking about addicts; I'm talking about gangsters and hit men. You don't think they're real? Live here. One of the guys above me has some pretty bold women parading through the halls, and you see them later walking the streets and talking to cars and truckers. Or you can see them disappearing into the shabby motels. One of them I'm actually friends with. We met at one of those parties, and now we shoot up every once in awhile when we see each other. Leila. Leila is what you could call my only friend now. There was a younger girl. I never learned her name, but she used to stick around Leila. I think they were sisters. I stopped seeing her around and asked one day.

"Hey, where'd that girl go? The one always with you?" Leila looked at me and gave a shrug. She got done tying the rubber band around her arm and looked me dead in the eye.

"She died. She was working a party, and someone slipped her too much of something. Bitch didn't even watch her own glass." She shook her head. I couldn't tell if it really was indifference or if this was just so common she'd learned not to care.

My apartment, my shack, I don't know what to compare it to. There's two rooms, a main room and a bathroom. I have a mattress on the floor, a mini fridge, a microwave, a small antennae TV in front of a recycled recliner, and a cracked bathroom mirror. The mirror reminds me of who I was and who I am now. I see the bags, the bones, the stringy hair, and the dirty yellow walls behind me. Mostly in here, you see empty bottles,

overflowing ash trays, and two dirty pots on the stove. There's about five spoons sitting beside them. You look in my trash, and it's worse. Sometimes a stray needle ends up on the floor or in the corner.

I spend my days working at the mini mart. Then I walk around. Or I do laundry. Or look at cars and pretend I can actually afford one. When I need to, I go grocery shopping. I don't shop at the mini mart though.

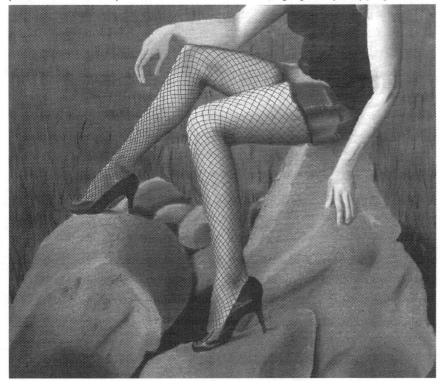

Oil by Kate Smith, Senior

I hate that place. I usually end up getting food from other local places, but not the mini mart. One time I was on some kind of tangent and walked all the way into the city, into the real city, and looked around at all the places I used to go. I stayed away from Boston Commons, though, and the damn fountains, the damn bushes. I walked to my old apartment. There was a fireman sticker on the window of my old room. I guess whoever is in there now probably has kids. I walked to Atlantic Breeze and stared at it from across the street. I saw Teagan and Rocky walk in together, laughing about something. I remembered that that night was a guest band night. I got a huge knot in my stomach, and then I saw Martin peering at me through the curtains. When he saw that I noticed him, he waved, and held up his finger telling me to hold on a minute. I turned and walked away as soon as he disappeared behind the drape. I haven't gone back there since. The whole time I was walking away, I was blinded by my old memories of playing, of Marnie's, and the fans. Then I remember the guest musicians, the parties, and the place I'm in now.

I was on my way home and stopped into one of the grocery stores within the city for a change, somewhere where I knew I wouldn't have to worry about who was behind me or who was driving by outside. People were looking at me going inside, but I tried to ignore them. I deserved it anyways. I stopped dead in my tracks when I was good and into the store because I saw Derek, the drummer I used to play with. He was at the seafood deli. I heard him buying two salmon fillets. Salmon fillets. Before he could see me, I slipped into an aisle, and went looking for mac and cheese and generic Cheerios, about the only food I ever keep in my cupboard. After I left the store, I kept thinking about the looks people were giving me and about how I must've looked to them. That whole walk home I cried, and as soon as I got back to my place, I went after the stock and got it all set up. I went overboard. I woke up on the floor bleeding out of my nose and with a cut on my shoulder. I could hardly see straight, and my legs didn't want to work. My voice croaked when I tried to make a sound. It scared the hell out of me.

I've overdosed five times since then, not all from heroin, not all by myself. I still wake up every time. Three times I woke up in a hospital with tubes in my throat. *Tyler.* My brain always flashes to pictures of him. Then I shove them away. I don't know a Tyler. Tyler's nobody. And this is nobody's fault but my own.

I don't know for how long, but this is my life now. Think it can't happen to you? It happened to me.

Unspoken Secrets

Poetry by Breanna Kretchmer, Senior
Oil by Kate Smith, Senior
Scholastic Art Gold Key

I am quiet, I am secretive.
I wonder how the past has affected me.
I hear words of broken promises.
I see the walls I've built crumbling around me.
I want to disappear for just one day.
I am quiet, I am secretive.

I pretend to listen to my parent's lectures.
I feel like I'm floating under water.
I touch the dark side of the moon.
I cry when I think of things that could have been.
I am quiet, I am secretive.

I understand I'm not perfect.
I say I'm fine, even if I'm not.
I dream of being able to speak my mind and not be too scared to just let go.
I try to make everyone happy.

I hope they know I do care.
I am quiet, I am secretive.
I am someone you will never fully understand.

Light & Dark

Poetry by Kelsey Piotrowicz, Senior
Charcoal by Kate Smith, Senior

Light:
"Hello, my name is I Get Straight A's," my name tag reads.
I'm of a cerebral species,
Not indigenous to hilarity or the manipulative nature of TV.
Singing inhibits me, whether intentional or not.
I am the melody of the song, not the harmony.

"She will succeed" is labeled on my forehead in red ink-
A stamp of authorization from my parents and teachers.
I pursue commands instinctively,
A people pleaser, a perfectionist.
My mind wanders between here and where I will be.
Dreams are incessant realities.

"She's perfect" he tattooed on my back.
I'm enveloped by his love-
A contemporary component of my makeup.
Life is a choice, and I always choose to believe that
"All you need is Love."

What am I?
An idiosyncratic amalgam of ingredients
Designed at birth to prosper,
Blended to the tune of edification and love.

Dark:
I'm subject to my drive for perfection;
I'm chained to my mind's introspection.
I've been this way for so long,
I'm perpetually losing my confident song.
Today, I wake up not knowing how I feel,
Scared that what I survey is conceivably real.
"My mind, my body, none is good enough for
 you!,"
To my inadequate self, I scream this truth.
In the tongues I taught myself to speak,
I don't know when I became this weak.
I crave the fruit of sweet bliss
When my self-made shackles won't be missed.

FIRST Impressions

Prose by Nicole Noland, Senior
Charcoal by Autumn Whiteman, Sophomore

They say that people can tell what kind of person you are within ten minutes of meeting you. First impressions are something you can never change. People usually decide in less than three seconds if you are worthy of their interaction or not. I disagree with this. I'm living proof that preconceived notions can be, and usually are, incredibly inaccurate.

Now, I'm not claiming to be utterly unbiased. Let's face it, I was raised in a predominantly white, Protestant, middle class environment. Of course, I'll be slightly biased. However, I was not raised and nor do I consider myself racist in any way, but I am guilty of stereotyping. I'll be the first to admit, I subconsciously label people. It's probably the biggest irony about me, because I'm so completely against being put in a box. A thought will pop into my head, my subconscious foot will kick me in the subconscious rear end, and I'll think to myself, "Knock it off!" Every time I do it, I secretly hope the person in question will totally prove me wrong. More than half the time, I'm right. The other half makes my day.

The happiest mistake I've ever made was when I met one of my mom's old friends from high school. I remember it in vivid detail because I was so surprised and amused. I was aimlessly walking around inside of Fun F.X., looking for something to go with my Halloween costume. I wasn't going to just be a vampire. Oh no. Like always, I had to be difficult and make it too specific. I was "that one girl vampire at the end of Fall Out Boy's a 'Little Less 16 Candles' video. You know? The one who bites Patrick on the neck and attacks him. Yeah. I'm dressing like her." Honestly, it was too much effort. I finally gave up and wandered through the aisles, looking for my mom. I eventually spotted her talking to this...guy. Grabbing a spray can of pink hair dye (Hey, she had pink hair! Maybe then people would recognize me!), I swaggered over to her. I already knew what would happen. She was going to introduce me, and I was going to use my "phone voice" to give the impression that I was the model daughter. He would tell her that I was getting too big, then we would walk away. Thankfully, that didn't happen. I threw my hair color in the cart and looked up at him. He

practically screamed "stoner." Long, tangled hair fell in his face, covering his squared glasses. He had an overgrown goatee that covered his lazy

looking smile. He was tall and thin, and his arms were full of latex skin and fake blood. I could see his tie dyed t-shirt, emblazoned with a picture of a wolf and ripped up jeans. I looked

back at my mom. She actually looked happy to see this guy. Grabbing my wrists, she yanked me over to him. I continued to stare. "Honey, this is Steve. I went to high school with him." I fake smiled at him, extending my hand. But...

Then he opened his mouth.

He had the softest voice I'd ever heard. He enunciated correctly and spoke clearly. I was taken aback for a minute. "God, Jackie. She looks so much like you, it's scary!" I immediately felt bad for thinking anything but good about this guy. I liked him at once. They made small talk for a couple more minutes. I learned that he was dressing as a zombie for Halloween; his group of friends went all out each year. My mom hugged him, and they both started back on their way. I waved back at him, and we got our place in the check out line. He sounded so familiar, I knew that my parents must have talked about him before. When we got into the car, I finally asked about him.

"Oh, yeah, that's Steve. He's great, isn't he?" my mom giggled. "Wanna hear something funny? He was our class Valedictorian." My eyes widened. "What's even funnier is that he looks the same as he did the day we graduated. The whole school's staff pooled money together to bribe him to cut off his hair. He didn't do it. We

seniors raised twice as much for him not to." I felt terrible for judging him for even a second. He sounded exactly like the kind of person I would love to be around. "He got a full ride to Notre Dame." Then she frowned. "He dropped out, though. People harassed him nonstop." I sighed.

"People like that suck." I silently crossed and uncrossed my fingers.

I really believe that. I mean, maybe in slightly more educated terms, but for the most part, I think that people who assume and preconceive are narrow minded. More specifically, I fault people who are aware of the truth and are apathetic to changing their minds.

Meeting Steve was one of the best things that ever happened to me. It taught me more about prejudice. He's aware of what he looks like. He's aware of what people think. Most everyone assumes he's only capable of saying things like, "Heyyy... mannnnnn...." Rather, he's an extremely intelligent individual. I respect him for not changing himself. That was almost two years ago. I still keep him in the back of my head and bring him up as an example when I catch myself scoffing at someone. It's a work in progress.

The Thankful Poor

(Painting by Henry Ossawa Tanner)
Poetry by Kayla Goforth, Senior
Watercolor by Garrett Blad, Junior
Scholastic Art Gold Key Award

To not know when your next meal is coming
yet praying and thanking God for what you have,
even the smallest morsel will do.

Longing for that one piece of butter bread,
the melting sensation that occurs when it's put in your mouth.
Your eyes roll back, because it tastes so good,
even the smallest morsel will do.

I close my eyes so father can pray.
All I can think of is how hungry I truly am.
Should I give father more since he is weak?
Maybe I shall quit school to help,
even the smallest morsel will do.

Our only clothes are dirty.
I go to the river to bathe.
A two room house we call a home
with the table that sees us once a day.
Here I sit thanking God for this food,
even the smallest morsel will do.

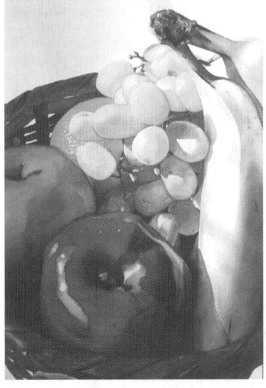

- The F Words -

The Cemetery

Poetry by Megan Snyder, Senior
Scholastic Writing Gold Key Award
Ink by Catrina Kroeger, Junior

How hot the sun is!
The shovel feels heavy in my hands.
 A train sounds in the distance
And all the other men crane their necks to watch
 It pass, a brief respite from the
Back breaking work of digging shallow graves.
 The black smudge streaks across the landscape
Disappearing on the horizon.
 The forlorn souls return to their terrible task
While I survey the wooden crosses,
 Creeping towards the beach, like ivy upon damaged walls.
The graves are filled with the broken bodies
 Of the soldiers
Whose blood colored the hillside a garish crimson before mixing in the mud.
 Few of the simple painted wooden crosses bear
The wreaths of dirty flowers, wilting in the heat, dropping dingy petals to the ground.
 My duty is deplorable, seeing the people
Who gave up everything they had
 To fend off unwanted ruthless invaders.
My heart is as heavy as my shovel
 As I return to my pitiful task.

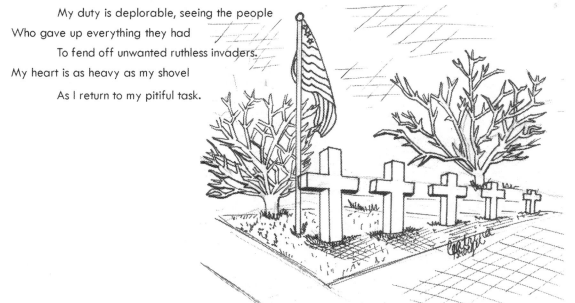

State of White

Poetry by Mark Davis, Senior
Pastel by Alysha Six, Senior

It all got so blurry,
a state of confusion
as it all went white.
Unknownst to me, my soul was lost,
just like a little white lie
just another battle, and I'm the cost.
It goes through my head like
veins in my wrist,
leaving a slate of white in the abyss,
a lost cause waiting to be redeemed
like any unseen scheme, realizing
it's just white noise entering and leaving a dream.
Lost in this white world with
no seen boundaries,
I walk a ridden world in my mind,
a simple white story
like anything unkind.

The Candle Flame

Poetry by Ayla Felix, Junior
Charcoal by Garrett Blad, Junior

A softly flickering flame,
Gently, silently keeping the dark at bay.
The white candle grows shorter
As the golden flame grows older.
It comments not on all it sees.
Silently, peacefully,
Keeping the secrets of eternity.
It judges not
On the actions done in its light,
For a candle flame
Knows no difference of wrong or right.

The Graveyard Shift

Drama by
Kate Smith, Senior

Brook, 19, is at work in a 24 hour, family owned diner at the outer edge of her small town on the highway. The dining room is completely empty except for one man finishing up his apple pie. It's two in the morning, and she's working with her friend, Alex, 20. Brook and Alex have a long past together, but in the months before, they had a breakup, leaving Brook heartbroken, and Alex in a hurry to pick up a new girlfriend (Tiffany) to hide his feelings over the situation. The manager tried to not work them together too often, due to the awkward tension she knew was between them. However, every Tuesday night they did work together on the graveyard shift, being the only two who were available on Tuesdays. The nights often entailed Brook meticulously cleaning and arranging the small dining room, and Alex doing the same in the kitchen. They can manage small talk, and usually stick to that.

(In the kitchen, Alex is scrubbing the grill, Brook is passing through.)

Brook: Hey, do you know where Ruth put the shipment of new dishes? I know they came in last night, but no one's actually unpacked them. Figured I might.

(He looks up with a bead of sweat on his forehead from the heat of cleaning off the grill.)

Alex: Um, yeah, I think they got set in the basement until someone cleared out the old dishes. Not enough room up here.

Brook: All right, thanks. I'm gonna get to work on those after I take care of this guy.

(She walks into the dining room and the man has left her just enough money to cover the bill and a fifty cent tip. "Well, that's what you get for working at an all night diner on the highway. People are tired and grouchy," she thinks to herself. After putting the money in the register, she heads to the basement. Alex watches her disappear down the steps, and shakes his head. She walks back up minutes later empty handed and stands in front of him.)

Brook: You think you can help me with the boxes? They're kinda heavier than I was thinking... (She gazes at him with a questioning look, seeming like she's not sure if she wants to say something or not) I need your muscles to even get them off the floor. (She offers a tiny smile.)*

Alex: Yeah, sure. Let me finish this real quick. *(She stands to the side of the grill, watching him. Whenever she starts looking at him for too long, she starts remembering too much from when they were together, and she looks away.)* You ready? He looks at her.

Brook: Yeah. Let's go.

(They head down the stairs to the dingy basement. There are two large boxes weighing about twenty pounds a piece. They don't have a rhythm carrying the first one, but by the second one, they're in sync together, and are both trying not to think about how easy it is for them to work on the same page instead of struggling awkwardly through the basement with the load. Then they both start thinking about things in their past. Things like when they worked together to move him into his first apartment, the way they danced together at each other's high school proms, how they always had the same pace when they walked side by side, no one needing to slow down or speed up. The second box makes it upstairs, and they set them both on the floor in the kitchen by the biggest counter area.)

Brook: Well, this'll be fun. Wonder how many hours it'll take to even clear all the old dishes out? I probably need to wash them down first. *(She doesn't really think it'll take long enough to kill the whole shift, so she throws in a new idea.)* "How about rinsing everything down?"

Alex: Yeah, well I've already cleaned everything down in the kitchen. Maybe I could help you? *(To Brook the statement sounds like a question to himself rather than her; she doesn't answer.)*

Alex: Yeah, it'll be easier with two people anyways. You can rinse, and I can stack the old ones in these boxes. Besides, I don't want you

dealing too much with the dishes. There's no way they'll all make it out alive if you're tossing wet dishes all over the counter. (He smiles.)

Brook (with a shrug): That's fine. Probably a good idea actually. I can take out the old ones, and you can rinse them. Then I'll dry and restack them.

(Alex situates himself at the sink, and Brook starts pulling plates and bowls down. For the first ten minutes they work in silence. Then Brook turns her head slightly to look at him while he rinses down the old dishes. She observes the new, close haircut he got after their split. She looks at the bags that always seem to be under his eyes. Most of all she sees the tension rolling off him. This closeness is just as uncomfortable for him as it is for her.)

Brook: So. What have you been doing lately? How's the apartment life going?

Alex (looks at her with surprise, then caution): It's going good. My roommate Trey got moved in last month. He's pretty cool, except for all the porno posters he's got all over every room. (Alex rolls his eyes. Brook thinks about how he never was very into that sort of stuff like every other guy seemed to be. Well, he was, but he wasn't interested in sticking posters of half naked woman everywhere. It was something she liked about him, even though he usually got teased for it.)

Brook: Hmm, just tear them all down and throw them in his room... Or find something he doesn't like and put it all over the apartment. Like kitten posters. (She smiles.)

Alex snorts: Yeah, good idea, so everyone can think that I'm a woman in disguise and love furry animals. (His friends all tease him mercilessly about how he's a neat freak, always doing dishes or cooking a real meal.) Good one. (He splashes a little bit of water at her.)

Brook: Hey hey, I'm just trying to help. (Pauses) So how are things with Tiffany? (She looks down at the plate she's handling, and turns her back to him to put it away instead of just reaching behind her.)

Alex: We're... we're okay. We're kind of in a rough spot right now..... Had a fight two nights ago. (He looks like he wants to crawl out of his skin, and it makes Brook want to drop the subject and apologize for bringing it up. Instead she stays quiet. After about twenty seconds of silence, he looks at her with guarded eyes, as if studying her, then backs down. Finally, she breaks the silence.)

Brook: Sorry. Look, I am sorry, okay, I was just trying to make some conversation. I figured it'd be going good, not something bad. Forget I said anything. (It killed her to see him in pain, clearly remembering something upsetting.)

Alex: It's fine. It's just hard to talk about with you, you know? It's not like I'd expect you to want to know anyways if it was going good.

(Brook, still longing to be good friends with him and just not knowing how, withdraws from the comment like she'd just walked in on a friend talking about her. She sucks in her breath and holds it. She doesn't want to go into a speech about how she still cares about him, and she wants him to be happy. She fears if she does, doors will be reopened they are both struggling to hold shut.)

Brook: Changing subject. Did you hear they're trying to put a new sandwich on the menu? Ruth's husband is like dead set on it, 'cause it's his sandwich, and it sounds disgusting. It's fried bologna with ketchup and butter. Ew. I mean, Eww! I guess she's not going to let him though. Said she doesn't want to kill any customers just yet. Too many years left to run the place. (She thinks about how she's babbling and stops. Alex looks at her with his head cocked to the side a bit, with a minuscule smile on his face. He's thinking about how she used to

Watercolor by Catrina Kroeger, Junior

babble when she was nervous.)

Alex: Yeah, sounds pretty disgusting. Maybe we should make a sandwich that could be put on the menu. (He looks at her again and smiles. The tension in the room, riding on her answer, is making them both sick. She nods after a moment of thought.

Brook: Yes, yes we should. What's in the cooler? (She's already dropped the plate and moved to the food side of the kitchen, away from preparation.

They spend the next hour throwing around ideas for sandwiches and wraps, melts and roasts, anything that could go on the menu. They become more comfortable with each other, making jokes and laughing, tasting miniature portions of things they make. Before they know it, they're talking about things from when they were together with little trouble.

Brook: Remember that day we went to the beach..... And the seagull?

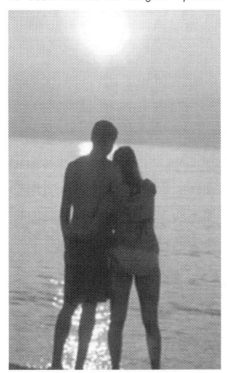

Photo by Karen Celmer, Senior

(She grins coyly.)

Alex: Yeah, thanks for bringing that up. Jeez. I mean really, he just had to let it drop right then, right there. I guess when you gotta go, you gotta go. (The two had only been dating for a couple weeks and were about to have their first kiss on the beach when a seagull relieved himself on Alex's shoulder. They both smile at the memory. They end up reliving the whole day, talking about their hike through the woods and swimming in the waves. They've become so involved in their versions of the

stories, they don't realize how close they've gotten to each other. Merely inches apart, they go on with that day at the beach until they come to the part about the kiss.)

Alex: You had on the blue and pink polka dot bikini... I remember your hair was all frizzy from the water. He smiles.)

Brook (puts her hands on her hips): My hair looked just fine, thank you very much! (She gives him a rough push on the shoulder.)

Alex (laughs): I guess I can't say anything, I mean look at how my hair looked at the end of the day! But hey now, no need to get physical. (He wraps his arms around her shoulders from behind and holds her tightly like they used to do when they'd wrestle. Brook is giggling.)

Brook: Let me go! You deserved that seagull anyways for when you dunked me in the lake! (She's trying to wriggle out of his grasp, and ends up turned so they're facing each other, still very close to him.)

Alex (snorts): Well, thanks so much. You know I was pretty interested in what I was doing. The bird kinda blew the moment. I was always mad at the bastard for that. (He looks at her deeply, as if trying to see inside her.)

Brook: Oh yeah? Now what made it so interesting? Just two kids on a beach... (She's trying not to squirm, trying to let herself play cool for what she can feel is coming. This is what she's wanted since they broke up.)

Alex (Pauses, again trying to predict her reaction. He stares into her eyes): I was on a beach with the only girl I ever really liked; I'd never

dreamed I could have that girl, and there she was in my arms. Her hair smelled like the lake, and I loved it. She went hiking and got muddy with me; she wasn't afraid to get dirty. Most of all, she was holding me, too, just like I was holding her. You were holding me. Brook, I never in a million years would have guessed you would choose me. I still don't know why you did.

(Her eyes have grown large, and her breathing is silent. His statement startles her, but before she has time to react, he starts to say something again.)

Alex: Brook. I'm so sorry. I'm so sorry for the things we've put each other through the last few months, and the months before we broke up. I never wanted us to end. As soon as you left that night after the fight, I felt like I let ninety percent of who I was walk out the door. I barely know how to do anything anymore.

Brook (High whisper): Tiffany?

Alex (Shakes his head): She's... She's not anything. Brook, the fight we got in? It was about you and me. She was messing around with someone because I still loved you and wouldn't admit it. I've been trying to ignore it, but these nights working here, they kill me. Seeing you by yourself, knowing I'm not with you, it kills me.

(Alex reaches up to wipe a stray tear off her cheek. This is more than she'd ever been hoping for. She's still holding her breath.)

Brook: Alex... I don't know how to do this. We've had our try, our rough spot, and-

Alex cuts her off by closing the distance quickly, and gently putting his lips over hers. The kiss goes on for what seems like forever, and yet it's not long enough for either of them. They slowly separate, but only an inch. When they take a step apart, the rest of the shift continues with an awkward feeling enveloping them both.

- The F Words -

The Golden Shoes

Poetry by Kelsey Dreessen, Senior
Pencil by Ashley Navilliat, Senior

Rainbow of color and style
From old to new for just a little while
Filed in your closet in neat little rows
Laces probably tied up in perfect bows
Each beautiful in its own way
But none so magnificent as the golden ones
You say
Lofty and put on a pedestal in your mind
With such high standards it's almost unkind
Still looking for a pair to rival
But none can compare and so sit in a pile
So many other gorgeous pairs
Any one good enough to make people stare
Each with stories and memories
Though not as loved as everyone can see
The only thing as wonderful as your golden shoes
Only in your eyes
You
And like so many others before
I've been left strewn about the floor

Taboo

Poetry by Kelsey Piotrowicz, Senior
Charcoal by Kate Jenkins, Senior

Taboo
A good friend's marriage to his LIFE-long PARTNER.
Taboo.
The neighbor's right wing robe as he picks up the paper from the left wing paperboy.
Taboo.
The Catholic Hispanic's engagement to the African American Baptist.
Taboo.
A respectable, religious relic openly displayed on the teacher's personal desk.
Taboo.
The pigtailed girl innocently asking the age of the silver-haired librarian.
Taboo.
The late night hours of HARD work between two very *passionate* colleagues.
Taboo.
Patriotic acts.
Taboo.
Men's roles. Women's roles. Debatable.
Taboo.
A survey asking the aristocratic woman her diplomatic weight.
Taboo.
An American unrightfully prejudiced towards a pure-hearted Muslim.
Taboo.
Little altar boys *serving* for priests.
Taboo.
The DEATH of an UNBORN child before its incipient breath.
Taboo.
Sex, sex, sex, sex, sex.
Taboo.
The booming shots of guns on alien soil.
Taboo.
Censorship.
Taboo.
FREEDOM.

- The F Words -

All For Show

Poetry by Kate Jenkins, Senior
Pencil by Ayla Felix, Juinor

The smell of popcorn
clinging to my clothes
refusing... refusing
to let go.
Plasma screen TV in the lobby
not even necessary, really,
but apparently, Americans have trouble being without...
without the constant entertainment
 the flashing colors
 the slogans, the catch phrases
 subliminally entrenching, clawing at the mind.
I hear commercial upon commercial,
a loop of maybe 4 or 5,
grating my teeth, counting the money made,
the crisp feeling of brand new one dollar bills in my hand,
paper clipping ten twenties
and dropping them in the slot to the left of the register.
Working in the summertime...

Showplace, surrounded by glass, is its own prison,
inescapable shelter from the warmth, the fresh air, the freedom.
Breaktime, a taste of the outdoors that I have been locked away from.
I receive the rations, a cup and a bag,
the smallest possible amounts of free food the management can dish out,
but as soon as it starts, it's over.
Back to work.
 Shoes on,
 name tag stabbed through my shirt,
 cheap bow tie clipped around my neck,
hoping I don't have to pretend to be excited to see anyone I know.
An old woman enters, the classic denim jeans with an elastic waistband.
I've learned the two types of old people by now:
the sympathetic grandmother/father figure,
and then, of course, there's the bitter kind, always whining about "the good old days."
I can already tell she is part of the latter group.
She scowls after I tell her the matinée price,
six dollars, as it has been for the past few years.
"They just keep raising the prices don't they?" she asks, condescendingly shaking her head.
I smile, knowing I look insincere... but I don't care.
"Not recently," I reply, trying not to let my irritability show,
thankful for the sound of the ticket shooting out of the dispenser,
a welcome distraction...
As I prepare to say the classic line that rolls off my tongue now,
I don't even give it a second thought,
meaningless words to another meaningless person:
"Enjoy your show."

Masquerade

Poetry by Jessica Figueroa, Senior
Photo by Jessica Figueroa, Senior

She always looked down

never smiled and wore a crown

she never wore her real face

wherever she goes she's out of place

her hair is long like an ocean wave

her skin is whiter than a corpse's grave

her eyelashes cover her tears

she has held them in for so many years

her lips soft colored with a bloody red

she's lain for what seems forever in this bed

the light shines and shows her complexion

She can't stand her own reflection

Waiting in the Dark

Poetry Renga by Autumn Ladyga,
Adam Novello, Megan Snyder,
and Kayla Goforth
Oil by Nicole Noland, Senior

I sit all alone,
being my own best friend,
knowing nothing of the world.
I feel like I need to pretend to be

someone who matters or
someone who cares.
Lost in the fragments of isolation,
I wish that I could

be swallowed by the dark oblivion
lying in wait for me, with claws and fangs
dragging me down into the place where
I can wait for the hands on the clock to

tick by, letting me know that waiting
is the only thing left to do,
and for now,
I sit all alone.

FIDELITY

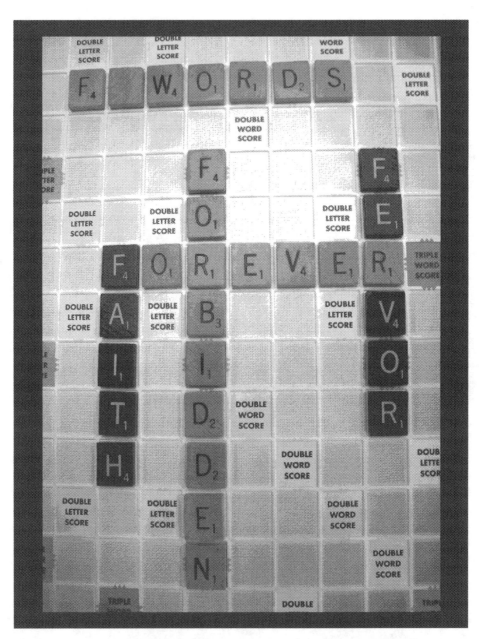

Feeling frisky? ***Fidelity*** *is just one of many F words*
that can fill our minds and hearts with love, faith, passion and desire. Follow our writers
and artists as they focus on the many splendored, fickle, flirting, and fond feelings that
can lead one to forbidden fruit and the forget-me-not.

Heart Eternal

*Poetry Renga by Kelsey Piotrowicz, Mark Davis,
Breanna Kretchmer, Audrey Mahank, Kaitlin
Cassady, and Kelsey Piotrowicz*
Watercolor by Brittany Tripp, Junior

The life you hold belongs to me.
Lock it up, and keep the key.
I trust you know the power behind
the arduous act of giving what's mine.

My heart is yours for the taking,
to hold dearest the love we're making.
Buried within my soul like hidden treasure,
love for you beyond any measure.

Our souls intertwined together,
a scorching blaze that will burn forever.
In my heart a beating desire,
the fuel to the everlasting fire.

I'm aching for your touch, my love.
I've received a sign from above,
that you still care about this fragile soul
that is no longer in an obscure hole.

Waking up from this nightmare,
in your arms again I appear.
Looking into the face of the one I love,
thanking the Mighty One above.

The moon above plays its last pawn,
your arms around me, breaking dawn.
The heart is like a chiming bell,
striking eternally our lives to tell.

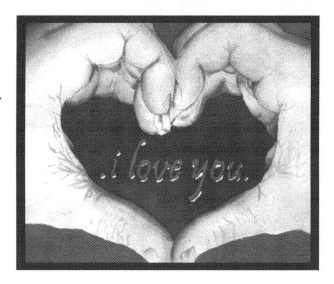

Faith Eternal

*Poetry Renga by Audrey Mahank, Kaitlin Cassady,
Kelsey Piotrowicz, Mark Davis, and Breanna
Kretchmer*

Faith is such an awesome word
The most simple word I've ever heard
To believe the unseen
Some find it obscene
But I love Him
And my heart shall never grow dim.

I feel in my heart we're meant to be
Keep me forever, never set me free
I'm deeply in love with this Man
Praying one day He'll take my hand.

You're with me in this eternal walk
The ethereal spirit through me talks
A love beyond all possible measure
Every soul on earth you made a treasure.

The feeling within me is so deep
Reaching ends that can't be reached
Whoever I am you love me so
Your river of love never ceases to flow.

You laid down your life for all of us
I believe the faith, in God I trust
I dream of the day when I see your face
I'll stand in the light of your eternal grace.

"Ya Gotta Love It"

Prose by Kelsey Piotrowicz, Senior

Pen and Ink by Ashley Navilliat, Senior

Love. How do you use the word? To explain your addiction to chocolate cake? To describe the bond you have with someone? People use it for different reasons. Many times though, "love" is used nonchalantly. "Love ya," is a common goodbye phrase. We often use remarks like, "I love your hair!" to express a liking of an object or idea. I even find myself using "love" in this casual manner.

But what should love connote? "True love" should be more private, with a greater implication. There's no textbook definition that can quite explain it. You're more likely to find your answer in life. If you can say you would put yourself in the way of harm for something or someone else, you've reached the level of ability to use the word. A soldier loving his or her country and putting himself or herself in danger to protect it, a mother giving her bedridden daughter a kidney, a man promising to take care of his soon-to-be fiancée for the rest of his life is love. The phrase, "I love (enter word of choice) to death," is a literal interpretation of love's significance.

The public use of the word "love" will probably never change. People will continue to use it, blindly oblivious to the implications the term carries. But, that's what America does. We take an idea and lower its seriousness completely to fit the culture. The damage has been done to Love.

Differing Differing Views

Poetry by Jessica Verkler, Senior

Watercolor by Ayla Felix, Junior

I stare at the TV. Nothing decent is on.
I will sit in this chair until the break of dawn.
Tonight he will not sneak out.

He looks out the window, lust overcoming him.
I smile because he doesn't think I know.
The TV blares on, hiding my malice.

He thinks that I'm stupid and wants to leave me.
I watch him as he gazes over the trees,
But he can't go anywhere if I don't leave his side.

I hate him for what he does to me, yet if he left, my life
 would end.
I love him; there is no way around it,
So I will keep him from seeing her, in my vain attempt to
 hold on to his love.

*I watch her as she sits in her chair. The TV is on, but no sound
 comes out.
Her thinking has been erratic tonight,
Much more than usual.*

*She watches me with a scrutiny I've never seen before.
I've grown used to her ways; I know she can't help it,
But tonight I am beginning to grow worried.*

*I look out the window at the other apartments across the
 street.
I see the lights on in some windows and I wonder who lives
 over there.
What are their lives like? What problems do they have?*

*I stare at my wife. I love her, and I would never leave her,
But she is beginning to become too much to bear.
Her disease is taking over, and there is nothing I can do to
 stop it.*

The Love of My Life

Poetry by Kaitlin Cassady, Senior
Photo by Kaitlin Cassady, Senior

I'm holding your tiny, frail body against my chest, your face a healthy shade of pink.
Your little hand wraps around my pinky finger and squeezes with all its might.
I don't ever want to let you go.
You have your daddy's eyes, blue like a blue zircon gem.
I never thought love at first sight existed until I saw you, yet I fell in love at once.
You made everything I went through those nine months worth it.
I can't help but to love you.
The socks you have to wear are too big for your teensy feet.
I hope you will grow to be a beautiful, strong, independent young lady some day.
Hearing you cry, with a snort, sounding much like a pig,
You're my beautiful, bouncing baby girl.
I wouldn't have done anything different; you make my life complete. Without you, my life
Would be nothing compared to what you have made it.
The way you smell after a bath, your brown hair dried in a fresh
Mohawk,
You're perfect, like a flower after a spring's rain.
You will always be my baby; I will love you forever.
You're the love of my life.

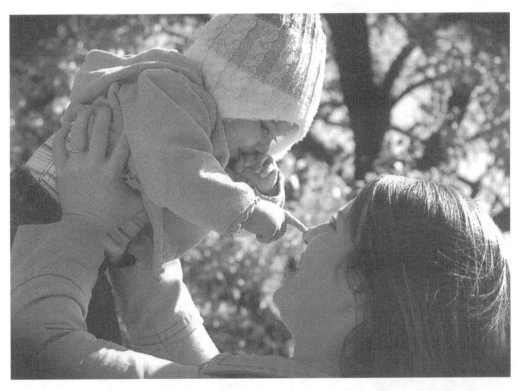

- The F Words -

Tony Ray

Poetry by Allison Adkins, Senior
Watercolor by Allison Adkins, Senior

For the one man in my life who has cared for me when no one else has

The man that didn't care when I was chubby

Didn't care when I was mean

Who helped me through my deepest of depressions

And kept me from taking my life.

The only person in the world who ever meant anything at all to me

The only man who ever needed me like I need to be needed

The only one I know who can look at me

with those beautiful green eyes and tell me the three words

that I don't want to hear and make me love to hear them.

The "I love you" keeps my heart beating

my lungs breathing

my existence being.

Floral Harmony

Fiction by Kelsey Piotrowicz, Senior
Oil by Kayleigh McMichael, Senior

I'm a florist. My store is quaintly squeezed in downtown New York between a small grocery store and a thrift shop on Statue Street. You'd never notice the place, if it weren't for the beautiful display of fresh flowers I try to arrange in the store's front window- a Technicolor advertisement that needs no words. Flowers speak in reds, oranges, purples, yellows, and pinks. They can draw the most subtle smile from the most down-beaten person. I'm a twenty-six year witness to their intoxicating tongue.

Today is a day like any other. Big George comes in for his weekly daisies, a colossal smile plastered on his round face. His massive bouncer frame intimidates the scrawny high school kid that's in to pick up his prom flowers. I strive to stifle my uncouth laughter.

"Hey, George! Here's your mom's pink daisies. I added a couple violets to it this time. Give her something more to look at," I tell him.

"She'll appreciate it. It will be a nice stimulus in that dreary hospital room," he says compassionately. I notice that sincere tone in his serious eyes.

"I thought it'd be a nice touch."

"So when are you finally gonna let me or someone take you out?" he asks with an innocent smile.

"When people start acting like flowers," I reply.

"What do you mean?"

"Well, carnations don't get an attitude if you forget an order; baby's breath is always charming, and lilies NEVER try greasy pickup lines. So, yeah."

"No one has a chance, do they?"

"Pretty much... no."

"Well, just remember one thing, flowers don't last in COLD, BITTER weather."

"I'll remember that. Thanks."

"No, no. Thank you for the flowers. I got to get going to the hospital. See ya next week?"

"Next week. Tell your mom hi for me."

He saunters away as his brawny arms carry the delicate arrangement of flowers. The contradicting components make me giggle a little. His comments meander through my mind as a couple more clients come in. A silver-haired woman and her peppy cockapoo come in and

- The F Words -

buy a bouquet of carnations. More prom boys and girls come to pick up their ribboned corsages and boutonnières.

Then he walks in. One can tell he's a pianist. His elongated fingers clutch a book of Debussy's piano concertos. He's tall and thin, like a redwood. Russet hair stops neatly at his forehead. It accents his olive eyes; they reveal his twenty-something youth. He wanders around, apparently looking for something. I've seen him many times before. We've talked a little, his deep voice an ironic comparison to my airy one. Christian appeared in one of my dreams before, the day after I met him. I don't know why, to be honest. I guess I'm slightly intrigued… or a lot intrigued. I don't think I want to be, but I am. Life hasn't gone my way before, but maybe this time…

"Can I help you with something?" I ask politely.

"Oh, hi," he says nervously. "Um, I need flowers."

"Well you've come to the right place. What are they for?"

"My sister. She's playing at Carnegie Hall tonight." He appears a little nervous, as he fidgets with the leaves of a nearby ficus tree.

"Wow. I feel largely unaccomplished and insignificant now," I say with a laugh.

"Well everyone in my family has graduated from Julliard. My mom's a cellist; my dad's a violinist. My life is musicians and music. You're different. You're the only person I know who deals with flowers. So I guess that makes you significant… to me at least." He smiles slightly and looks at me with piercing eyes.

"Um… thanks." The butterflies erupt in my stomach from their cocoon.

"You're welcome. So, uh, the flowers." He knows he said more than he wanted to.

"Right. So, what does your sister like?"

"I don't know. What's appropriate for a flautist?"

"How about a dozen orchids? Elegant, yet, simple."

"That sounds great." Christian watches me as I begin to round up his flowers. He's still nervous but with interest now. The clutch on his book tightens. "Um… so… what's your favorite flower?"

"I've been a rose girl forever. Classic. Ribbon color?"

"Blue, I think, please." I put the final touches on the bouquet and ring it up.

"It'll be fifty five sixty four."

"Ok." He digs the money out from his pocket. "Thanks a lot. It was nice talking to you."

"You, too. Come back again!" I yell out loud. *Please come back,* I think to myself. The rest of the day goes quickly, as thoughts of him flood my mind. I head upstairs to my apartment as the sun tucks itself into the west horizon. I eat my dinner of salad greens and grilled chicken solemnly. The TV is the only voice I have to respond to. Life is beginning to look more solitary. I shower and jump in bed to sleep, and before too long, there Christian is again.

I wake up, eat my daily grapefruit, and head downstairs to begin the day. As I flip the sign on the door to *Open* and unlock the door, I see two dozen red roses sitting outside the store in a crystal vase. There's a note attached.

To someone as classic as a rose. Pick you up at 8. (That's when you close.☺*)*
 -Christian

This is a determining point in my life. I have two choices: 1. Forever continue to be afraid of the influence of people in my life. 2. Face the music and go for it. I walk to the door and flip the sign back to the *Closed* side. Today, I get the day off. I think I need a new dress…maybe something floral?

Red Passion

Poetry by Kelsey Piotrowicz, Senior
Photo by Brooke Poeppel, Senior

Red passion causes the burning ice
around me to break and groan to the floor.
The stubborn stone in my mind gives way
to the wavering muscle in my hand
that reaches for you
as I faint into hot darkness.

I've spoken tongues for so long-
no one has given me the blue light
to fall as though
I will be caught.
Finally, I've bitten the sky, as blue as waves,
and will drift into locked arms and want no key.

Shades of Pink

Poetry by Kristin Whitaker, Senior
Watercolor by Amanda Bachtel, Junior

Pink.
The cheap wine we indulge in,
the color of my soft cotton sun dress.
Your fiery touch
hues my cheeks with blush.
The passion is real.
Your fuchsia fingertips brush my lips.
I want to be with you more than you can fathom.
The magenta sun sets behind us
as we both share many shades of passion between us.
However I know that this love we proclaim will never
be anything more than what we have.
We are merely two lovers who enjoy
the presence of one another's company.

My First Crush

Prose by Dan Meade, Senior

Photo by Kayleigh McMichael, Senior

The year was 1997. I was in kindergarten. She had blonde hair and like most kids in kindergarten, she was short. It was the first time I ever liked a girl. Up until now, I thought they had cooties. I didn't care if she had them, what they were, or if they were going to eat me. Nothing was going to stop me from letting her know I wasn't invisible.

The first day that I saw her, I was really shy. I would make it a point to sit by her at story time. As the teacher read the <u>Boxcar Children</u>, all I could think about was the girl sitting next to me. I never started a conversation with her though. I didn't know her name the first week of school.

One day, she

came up to me and asked me for a pencil. It was about the second week of school. I, seeing as it was my first grade ever, had plenty of pencils. I had a pencil box full of them. I told her my name was Daniel. She said hers was Angel. I thought that it was so cool that her name was Angel. I talked about her to everybody, "Angel this" and "Angel that!" To me, she was the prettiest girl I had ever seen.

It wasn't but a month later that she moved away, no goodbye, no telling me where she was moving. She just left. She left me there in kindergarten, feeling alone. I moved on soon after though: Krysta Kyrpan. Same class, same grade. Young love is a funny thing, isn't it?

 And

You loved me and I loved you,
we thought it would last forever
when xoxo was all we knew.

We once thought this love was true,
with all those days we spent together,
you loved me and I loved you.

We didn't care what our parents would do,
we would've run away together
when xoxo was all we knew.

I wished that it could be just us two,
till death do us part, always, forever,
when you loved me and I loved you.

I thought I would never lose you;
I thought we'd grow old together
when xoxo was all we knew.

A fairytale ending with me and you,
we'd be in love, together, forever
when xoxo was all we knew.

But life's no fairytale
and love's often untrue,
and x's and o's are simply letters, too.

Poetry by Breanna Kretchmer, Senior

Charcoal by Kate Smith, Senior
Scholastic Art Honorable Mention Award

A Mad Dash through Paris

Drama by Megan Snyder, Senior
Pencil by Kate Smith, Senior

[A boy and girl run through Paris.]

Vivienne: I told you we were lost. You never believe me! We took the wrong turn at the Galerie Saint-Didier.

Tristan: I know where we are. I know it! [looks frustrated]

Vivienne: Obviously, you don't. Men are awful with directions. That's why it took Lewis and Clark so long to reach the other side of the continent, until they found Sacagawea. Oh! Stop! I HAVE to go in here! [She ducks into a shop, leaving Tristan standing in the street.]

Tristan: We don't have time for this, Viv! Our tour of the artist's square is not going to happen unless we get a move on. [She comes out of a dressing room in a black dress.]

Tristan: Whoa. [His jaw drops.]

Vivienne: Let me pay for this and we can go. [She smirks at him and slips back into the room, comes out a moment later with the dress.] [She pays and when they exit, they are holding hands.]

Vivienne: Where are we supposed to be again?

Tristan: I wanted to go to the artist's square, but seeing as how we can't find it, let's just walk. [They walk hand in hand for a while and stumble upon a church courtyard.]

Vivienne: You could paint in here. It's gorgeous! The fountain is perfect. [He smiles at her.]

Tristan: Go sit at the edge of the fountain for a quick sketch. Please?

Vivienne: I will... For a price. [She smiles coyly.]

Tristan: Oh? What price is that?

Vivienne: Surely too much for you. [She grins and starts to head back to the street.]

Tristan: Wait, Viv. It is really very pretty in here. Come on, what price?

Vivienne: Perhaps a kiss? [After a sweet little kiss, she skips over to the fountain and sits on the edge, dangling her fingers in the water.]

Tristan: [Studies her for a moment.] Push your hair away from your right cheek. [She complies.] Good, good. [She sits as still as possible as his charcoal pencil scratches away at his paper.]

Tristan: All done.

Vivienne: That was quick.

Tristan: You are an amazing subject.

Vivienne: Look! Signs for a museum! We'll get the directions for the artist's square in the morning. Can we go see it?

Tristan: Fine. I guess I have to put off my artistic vision until tomorrow. [He grumbles but is smiling as he does it.]

Vivienne: You are such a big baby! [She laughs and they head to the entrance to the Museé d'Art Moderne de la Ville de Paris.] [They gaze at paintings and sculptures, Vivienne snapping photos all over.]

Tristan: Viv, what time is it? [She glances down at her watch face.]

Vivienne: It's a quarter to seven. Why?

Tristan: Oh Lord. We have to go! [He grabs her hand and yanks her through the crowds to reach the exit. They burst out onto the street and sprint for the bridge on Avenue Bosquet.]

Vivienne: Tristan, you are seriously scaring me. Where are we going?

Tristan: It's a surprise. For me to know and you to find out. [He hails a white taxi and they jump in, holding hands in the back seat. He tells the driver something in rapid French that she can't understand. She notices the black structure of the Eiffel Tower growing closer as they speed over the bridge and down packed streets. They jump out of the taxi in front of the tower. He pushes her toward the bathroom.]

- The F Words -

Tristan: Go put your new dress on.
Vivienne: Why?
Tristan: [exasperated] Please. Just do it.
Vivienne: Fine. [She stomps into the bathroom. When she comes out, he is waiting for her. He has changed out of his jeans and hoodie into a black button down and black dress pants.]
Tristan: Viv.... You look gorgeous.
Vivienne: You look pretty dashing yourself. [She kisses his cheek and he takes her hand. They move toward the entrance to the tower.]
Vivienne: Will you please tell me what is going on? You know I hate surprises.

Tristan: I know you hate them. But this one you will have to wait for. [She pretends to pout with her arms over her chest as the elevator to the top begins to ascend, but she can't help a smile on her lips. The doors open onto the balcony overlooking all of Paris. Both of them suck in a breath and move to the railings, taking in the sight of the city as the sun sets. He pulls away from the ledge and takes her hand in his and drops to one knee.]
Tristan: Viv, I don't know how to make you see how perfect you are to me. You are everything that I could ever want. I don't ever want to lose you. Losing you would be like losing the ability to breathe. [Her eyes fill with tears here and she presses her free hand to her lips.] Do you remember when I told you that I wanted to come to Paris and propose at sunset... [She nods.] Well, this is it. [He pulls a black velvet box from his pocket.] Viv, will you marry me? [He opens the box. A ring sits inside it. The band is delicate silver, a shiny little pearl set in the center, surrounded by tiny diamonds.]
Vivienne: [Gasps.] Oh... Tristan...
Tristan: I know you don't like surprises, but this was too good an opportunity to pass up... And I had hoped this to go better. I had a whole speech thing prepared...
Vivienne: Well... [She sniffs and tries to brush away the happy tears from the corners of her eyes.] Do I have to put this ring on by myself? [She laughs and pulls him up by the collar of his shirt after he slips the ring onto her left hand.] Yes! ¡Si! Oui! Yes, in any language! [He wraps his arms around her and gently kisses her lips.]
Tristan: Good. I wouldn't have let you say no, anyways.
[They laugh, and he spins her around the balcony in a twirling dance in the light of the setting sun in Paris.]

End Scene.

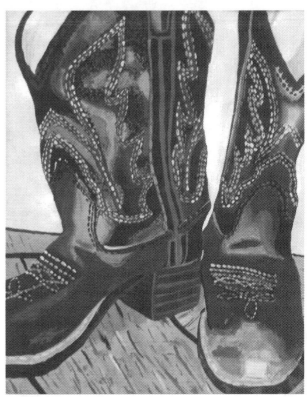

Optimistic

Poetry by Lauren Kipper, Senior
Tempera by Emily Thomas, Junior

You stand there with your elbow on the fence post,
eyes that are the same gray as the open sky look back at me.
You reach your arm out and grab my waist,
smiling just like the calm before the storm.
We carry on our conversation, quietly whispering in each
other's ears so no one will hear, but there's no one near.
We could scream our words, but they would be lost to the wind.
You talk about our future,
as you wrap your coat close around me.
Your one wish is for me to run off with you to Tennessee.
As I take in the strong smell of horse and cologne,
you spill your hopes of returning to Tennessee
and how the thought has danced heavily on your mind.
You promise I'll love it there
with all the wide open spaces.
The scent of rain surrounds us
as leaves in hues of orange dance around our feet.
We take off dancing through the rain like little children.
You pick me up and carry me through the barn door,
just like your optimistic outlook carries me through.my days.
How you do it, I'm not sure.
Life throws you down but still you stand.
Take it with the cowboy prayer and keep fighting is what you've taught me
while I teach you what it's like to be loved by a steady soul
who stays in one place for more than your average of a year.
As the rain quits, we still savor the moment
and smile
and you say, think of all these moments still to come.

Doggie Kisses

Prose by Alyssa Wiegand, Senior
Watercolor by Kate Smith, Senior

I believe in the power of dog kisses. I know this must sound silly and juvenile, but I know for a fact that one dog kiss equals at least one week of therapy. My last few years of high school have been long ones, and more then once I've made the 10-15 minute drive home in tears after one thing or another that happened. Usually when this happens, I sit in the car composing myself. When I'm finally ready to open the door, Oliver is usually sitting there and is insanely happy to see me.

Oliver is my baby. She is a lovable mutt, mostly black Lab, with who knows what mixed in to a small degree somewhere down the line. She will eat nearly anything, and although she is fully grown, she still thinks she is a lap dog of the cutest and snuggliest variety. She shakes with both paws, too. She also seems rather in tune to my internal emotional environment. No matter what kind of day

it's been, when I get home, Oliver is waiting, tongue lolling, tail wagging a mile minute, right outside my door. She jumps in my lap, licks my face and sniffs my hair until I give her a kiss on the nose and a big hug. Post hug, she hops out barking to tell my other beloved mutt, Hershey, of my arrival. Hershey is an old lady now, and doesn't get quite so excited anymore.

I really look forward to this encounter everyday. When it's been an exceptionally rotten day, Oliver licks all the tears off my face and sits on my lap sniffing my sweatshirt while I hug her. She always seems to know when I need her the most. This is why I believe in dog kisses; because no matter what kind of day it's been, a little slobber and a few doggie hugs always manage to heal me and remind me there are still a few good people in this world; some of them just have four legs and doggie breath.

Addicted

Poetry by Rachel Simms, Junior
Charcoal by Ashley Navilliat, Senior

Late night whispers and laughs while butterflies within me awake,
Oh, those summer nights.
My heart was enraptured when we first spoke,
And my fancies have taken numerous flights.

Your smooth, addictive voice takes captive my mind;
Do you know what you do to me?
When I'm near you, to any other, my eyes are blind.
Won't you finally call me yours and set my senses free?

My thoughts rarely stray from you, my love,
For I so badly want this to be real.
You are all I can think, all I can dream of,
Our very own fairytale as if from a movie reel.

In my heart I know this to be true,
I may never recover from you.

- The F Words -

Elizabeth

Poetry by Cody Pritchett, Senior
Photo by Kayleigh McMichael, Senior

For beloved Elizabeth,

whose black heart is only rivaled by her deep eyes

whose physical appearance is unmatched across the ages

who says one thing and means another

whose voice echoes ever in my ear

who is unsure of what she wants

whose emotions are high and ever clear

who is obsessed with vampires

whose smile glows into my heart, warming my very soul

whose deep eyes widen at the sight of me

who comforts me with her benevolence

who plays at my heart

who is gone.

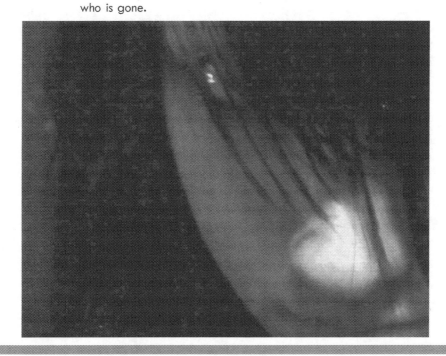

Wife Sells HUBBY'S ORGANS in Online Auction

Fiction by Megan Snyder, Senior
Scholastic Writing Certificate of Merit Award

HE isn't getting better. My husband Chase has been dead to the world for so long. Our children ask where Daddy has gone. I hate to leave the hospital. I want to stay with my husband but I can't take it anymore. I miss hearing him laugh. I miss gazing into his eyes as the morning sun shines through a crack in the curtains. He is my everything. He saw me when no one else could. I can't give him up. But I have to.

I met my husband in college. Most people's gazes seemed to flicker over me, almost as if I were the color of air. From as far back as I can remember, I was invisible and I knew it, though it never bothered me in the least. I had all the money and social standing in the world. My parents were the type of people who held fancy dinner parties with porcelain plates and tea cups, and held brunches with caviar. My family was rich beyond belief, and in high school I had used that to my advantage, being snobbish and alienating everyone in my life. Not until college did I sink into my quiet side. But Chase saw me. Heard me. Understood me.

For a research paper on a figure in Greek mythology, I spent many days and nights inside the campus library in a small alcove surrounded by stacks of outdated history texts, candy bar wrappers, and empty Mountain Dew bottles. Chase worked part-time in the library. I suppose I fell asleep one night. He woke me up from my dreams of a great Greek hero, one who slew gorgons and beasts and who looked remarkably like him. He shook my shoulder, gently. "Um, are you awake?"

"Obviously, now I am," I grumbled. I looked up into his eyes, the color of the mildly tossing ocean waves in the Caribbean. A girl could trip and fall hard into those eyes if she wasn't careful.

"You look pretty stressed out."

"I am. Huge paper for my Classic Civilizations class."

"Let me take you out and de-stress you." His smile could make a one million watt light bulb look dim.

It took every ounce of energy I had to stop myself from saying no. This boy had seen me when the rest of the world couldn't. Should I take a risk on that?

Finally, after much begging on his part, I couldn't resist. He was so sweet to me, making me feel (and believe, more importantly) that I was a queen. And slowly but surely, I fell in love.

He had wanted to become a reverend, follow his father's footsteps, though he never did. My husband supposedly had a fear of speaking in front of crowds. How he became one of the top lawyers for one of the largest firms in the state, I never understood.

Chase always talked about what could happen to us, accidents and fatal mishaps. He talked about what would happen to our bodies after our souls had left us when we died. I suppose that he spoke like that because of his father, the all-powerful and imposing Reverend Abraham Daniels. When he spoke like that it always scared me. Every once in awhile, I would have awful nightmares about the things that could happen to us. I dreamt of car crashes and broken glass flashing as it flew through the air and drove into my loved ones' flesh. I would wake up with tears raining down my cheeks, shaking uncontrollably. I would have to run to my children's rooms and hug them and cover them with kisses.

The worst day of my life was on a Thursday, October 16th. It seems like a blur to me now, but

- The F Words -

then, it was as if the world had slowed down to one frame per hour. Time seemed to stop. The police called when I went to pick up Sam and Fiona from school. Nothing seemed out of the ordinary until I pulled into the driveway and saw the police squad car sitting up by the garage. My heart plunged into my toes. What was wrong? I had no idea. I left Sam and Fiona in the car while I ran up to the door and almost began to cry right there on the doorstep.

A man in a police uniform was standing there on my front porch! I saw little black spots grow over my field of vision. My heart thundered in my ears and then... "Take me to the hospital, now!" I growled at the officer.

I sprinted for my car, calling over my shoulder that I was taking my kids to their grandparents' house. The officer followed me down the street as I raced maniacally towards the hospital. Now that I look back, I am surprised that the officer didn't pull me over for speeding and reckless driving.

Once at the

Pencil by Kate Smith, Senior

there with his cap in his hand. He was a state trooper. I remember reading the badge on his chest. He looked up at me with sadness in his eyes.

"Ma'am, are you Mrs. Daniels?"

"Yes. What's wrong?"

"Your husband, Chase Daniels, was in a car crash this morning. He was hit by a semitruck that crossed the median. He is at Holy Trinity Hospital. I am here to escort you to the hospital."

It felt like all of the air in the world had been sucked away into deep, dark oblivion. I felt my lungs constrict; I was suffocating out

infirmary, the policeman had to hold me upright and walk me through the doors. My legs were so weak that I could barely walk. We sat in the waiting room for what seemed like days. The disgusting, dirty mint green walls made me sick to my stomach. The chairs felt like they were made of cement. The officer held my hand. His fingers in mine were the only real thing keeping me tethered to the ground. I wanted to run screaming down the hallway, yelling for my husband. I knew I couldn't. My lungs wouldn't work right either. I couldn't draw in enough air to keep up my circulation. Both of my legs had gone numb from

sitting in the cold, ugly waiting room, with its peeling paint and drab gray chairs. The woman working behind the desk at the nurse's station kept glancing over at me and the officer. I didn't like the look in her eye, but I couldn't think about that at the time.

I regained the feeling in my legs and then started to pace around the small room. I bite my lower lip when I am nervous, and soon I could taste the hot, metallic gush of blood in my mouth. The police officer brought me a paper cup of water, and I rinsed my mouth out.

I continued pacing, for how long I don't know. It seemed to be hours. A doctor came down the hallway and stopped in front of me. "Mrs. Daniels?"

My lips couldn't form the answer, and I made an unintelligible noise at the back of my throat. Horrible thoughts were swarming around my head like angry clouds of bees. One thought would touch down for a second and then flit away, so that I didn't have to focus on one thing for too long. The doctor looked at me with sympathy in his eyes. I hated that feeling of helplessness; that every person who saw me looked at me with regret. I couldn't stand and didn't want this man's pity.

I cleared my throat and rasped out, "Yes. I am Eva Daniels. Where is my husband?"

The doctor took my hand in his and said "Mrs. Daniels, your husband was in a car accident. The accident was not nearly as bad as it looked. The semidriver walked away with a bruised rib. Your husband suffered a couple bruised ribs and a minor fracture in his left wrist."

"When can I see him? I have to see him."

"There was one other problem, Mrs. Daniels. Your husband

hit his head very hard against the back of the seat. His brain was damaged. He is in a coma right now. At this point in time, the prognosis is not very bright. He may never wake up."

I saw the drab, cold tile fly up to meet me, and then warm oblivion surrounded me. I don't know how long I was unconscious. The only thing I do remember is the complete and utter emptiness of my dreams. I walked down dark corridors screaming Chase's name, trying to find him. Every door I tried to open was locked from the inside. I screamed for him until my throat was raw. I woke up screaming my husband's name in a long hospital bed.

A nurse came over to me and said, "Honey, it's all right! You are fine. Your husband is down the hall. Come with me."

Cautiously, I crawled out of the bed, afraid of what I would see, and followed the nurse.

He was lying on a bed, bloody bandages around his head. Clear tubes sprouted out of almost every pore in his body. His eyes were closed, the lids twitching rapidly.

"Chase," I murmured as my knees gave out under me. I crumpled to the floor and sat there, staring at the man I had given my whole being to. I moved on my hands and knees to the side of the bed. The whirring and beeping of the machines scared me. I touched Chase's hand; it was cold and felt as thin as paper. My eyes traveled to his face. I couldn't hold back the freezing water that was flowing through my veins. My tears cascaded down my cheeks. I climbed into the bed beside my husband and fell asleep with frigid rain still falling, falling on his shoulder.

For a few stolen moments I slept, fitfully. Images of when Chase had proposed to me swam through my sleep. The golden sunlight of the afternoon poured down through the leafy tree branches, turning everything in its path a honey color. Chase laughed at me as I wiped my nose with a tissue. He always laughed when I sneezed, probably because I could shake birds from the trees with how loud it was sometimes! Inside the picnic basket was all manner of desserts that Chase had packed for us. His hand held a vanilla cupcake with beautiful violet icing on top. Sitting in the center of the icing was a delicate gold ring, stars etched along the band.

"Eva Jolene, as far out of your league as I am, I am utterly and irrevocably in with love you. I have been from the moment I woke you up in the library. I hate that I have no claim on you at all. I want you. I want you forever and ever until the stars fall out of the sky and crash to earth, which more than likely won't happen in a long, long time." Here he turned his million watt smile on me. "Will you marry me, Eva Jolene?"

My reaction was to gasp like a fish who has been thrown ashore by an exceptionally violent wave and is left floundering around on the sand. "Chase," I eventually managed, "you should have known from the moment you woke me up that we would be together forever." I slipped my arms around his neck and pressed a kiss to his lips.

Then suddenly I am awake, with a feeling of such loneliness that is a physical pain, a serrated knife between my ribs.

~ ~ ~

My parents came to see us later in the evening, that cold October day. They told me that the kids were fine. A part of me didn't even remember that I had children. I sat beside Chase for days on end. For all of those days he never woke up, never made any sign of being aware of his family. I cried so much and so hard that after some time, I couldn't produce any more tears. Weeks went past and slowly melted into months, and at length, the calendar said, a year. He never woke up. I don't think I woke up either. My mind was in a perpetual fog, until one morning.

I had been visited by lawyers almost every day, most of them trying to speak about my husband's condition. I knew deep in my soul that I would never see my husband's eyes light up again. I knew that I would never get to hear him laugh, that I would never get to have his arms around me. On a Monday morning I made one of the most devastating decisions of my life. Chase had always maintained that when he died his organs would be given to others who needed them. He wanted his life to mean something, to preserve others' lives. I knew what I had to do.

"Mr. Harris, I want the organ donation papers. I need to sign them today. I can't look at my husband anymore. It punches holes in my chest every time I do. I can't stand it." My voice cracked on the last word, and I feared that I would break down in front of the lawyer.

"I have them with me. And your husband's will. He left everything to you, as you already know, and wants his organs to go to 'people in desperate need of them.' He has left the process of the organ distribution up to you. We just need your signature here, on this form." He pulled a sheaf of papers from his briefcase. "Can I ask what you are going to do with the organs?"

"Oh, I have a plan. A plan to benefit more than one person."

- The F Words -

~ ~ ~

The computer whirred in front of me. I was so scared to do what I needed. I seated myself and typed in my email address and password. The website popped into view, and I couldn't catch my breath. *Come on, you can do this,* I told myself.

My fingers tapped out a rhythm on the keyboard. A glance down at the checklist on the desk beside me told me that the lungs were up first. Should they be $1,000

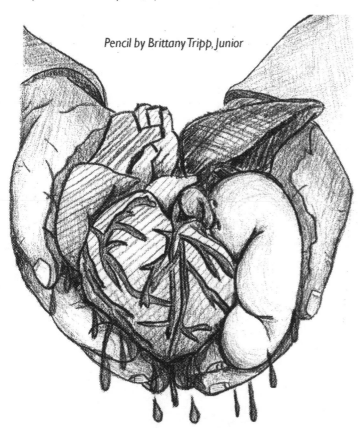

Pencil by Brittany Tripp, Junior

or $5,000? Would someone actually pay that much? How much should a pair of lungs go for? I had no idea. About $5,000 sounded reasonable. I hoped someone would pay that much.

I worked out a system for my husband's organs: between $4,000 and $5,000 for a major organ, like the lungs and his heart

and his liver, less for his colon and kidneys and pancreas.

His eyes were the first to go. It hurt to watch the bids for my husband's body flood into the website. My hands shook as the timer on the auction ran down. A man from France claimed my husband's eyes. He was legally blind and had applied for a transplant but had been rejected.

I took a trembling breath and resigned myself to my decision. Chase hadn't so much as fluttered

an eyelid since the accident a full year ago. The doctors had no hope for a recovery. Neither did I at this point. I wept every night for my lost husband, and I apologized for giving up. I begged any and all gods to give my love back to me. None of my prayers were answered.

A couple of hours passed,

and my husband's kidneys were claimed by a woman in Turkey. She had had cancer for about two years and was living off artificial kidneys. Sometime around midnight that same day, through the haze of my exhaustion, I registered that the computer was letting me know, through a series of irritating beeps, that all of my auctions had run out of time. My husband wasn't mine anymore.

I knew that what I was doing would benefit other people. My husband's sacrifice saved people's lives! That was incredible in itself. But I wanted to keep a piece of Chase for myself. On his right arm, shortly after we were married, he had gotten a heart tattooed in his skin with the words "Eva Forever" inside it. I had asked the doctors if there was a way to preserve it. As disgusting and macabre as it may seem, my husband's tattoo sits in a clear vase on the mantel in the study, a gory yet precious memento.

My husband and I had saved eight lives and bettered more than that with the gift of his body. I donated all the money from his organs to the hospital that had helped us through so much in that long, painful year. The memory of my beloved husband is still with me. I tell my children that their father was a hero and keep his legacy in them. I realized that most of Chase had been titled to another person. My husband wasn't mine anymore. I held no claim over him at all. I perceived in my heart that while I had had my husband, I had held a miracle. I was glad for the time we had spent together, even if it had ended too soon. Chase's body was given to strangers who lived in different countries.. Chase had always wanted to become a world traveler. I suppose, now, he would.

The Whisper of Water

The closest to heaven that I've ever been was on top of a sand dune at sunset, staring out into the water. I stayed up there as long as I possibly could, watching the waves crash into the shore, until I started shivering from the summer night. I stayed until my clothes had dried completely, and the grains of Michigan sand dropped off my legs with every step. To me, that's the essence of beauty in nature. You can have the majestic mountains and mighty redwoods that stretch up into the clouds. Nothing puts me in a state of awe more than water. I'm obsessed with the beauty of it. Everything. The smell of the lake water mixed with the scent of boat wax. The way the harbor at Lake Michigan is filled with sailboats and dinghies on any given July day. The sound the sailboats make when they rock back and forth in the water, patiently waiting to be untied from their piers. The cries from the greedy seagulls in the background. I love that lake. The irony of it all

Prose by Nicole Noland, Senior

Oil by Kate Smith, Senior
Scholastic Art Gold Key Award

is, I hate being in the sunlight. It burns my skin too badly. But when you're covered in baby sunscreen and a trucker hat, seated under the hull of a fishing boat, you kind of forget.

I'll see the ocean for real, one day. I don't *want* to, I'm going to. Staring at the live video feed of Huntington Beach in Cali in the inside of Hollister while my mom and brother shop for crappy, distressed shirts just doesn't compare. I'll stand at the shore and breathe in the smell of salt water air, and still, that vast amount of seawater will never replace my first love. Lake Michigan takes my breath away. More specifically, the lake and dunes of Lake Michigan take my breath away. It's something about the way you feel standing on top of a mountain made of sand, being able to see across the distance. It brings back the memories of when I was a little girl, wishing I was a mermaid so I could breathe underwater and stay there forever. Of taking pictures of the waves spraying into the jetty, crashing up against the lighthouse. I must have been a water nymph or something in a past life.

I'll always have a connection to the water. I'll always listen when it talks to me, the waves whispering to me, pulling me in. It will always be a part of me.

Buddha

Poetry by Jake Ladyga, Senior
Oil by Brooke Poeppel, Senior

The youthful Indian prince
The revered spiritual teacher
The jovial old Tibetan lama
The stone statue on a *Target* shelf.

The fat guy on the Chinese menu
The always-calm alley cat
The ancient oak without its leaves
The grandma baking cookies.

The beetle on the blade of grass
The construction worker on the highway
A silent summer, moonlit night
The pine-green thumbtack.

The deepest grain of ocean sand
To the highest flake of mountain snow
It's real, and here, and beautiful
At once none of it and all.

She may be drinking tea
Or he might be fast asleep
The breathing Buddha's buried
In the heart of everything.

No words can ever name it
It only knows the whole
Creed and race mean naught to it
It can only show us love.

From the compelling stupa of Bodhgaya
To the tiniest lilac bloom
Breathe and know you're part of it
Om mani padme hung...

Waiting

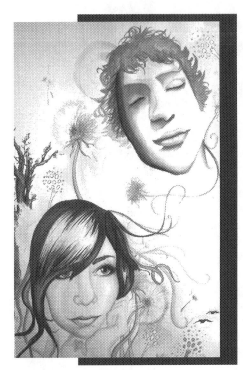

Poetry by Kelsey Piotrowicz, Senior
Scholastic Writing Gold Key Award
Oil by Brooke Poeppel, Senior

I sit reading the paper,
waiting for the rest of the party. They're late and I'm impatient.
I know he's watching. If he thinks we're going to dance tonight...
> *I'm observing her-*
> *the black lace cascading down her back,*
> *the chocolate curls swirled above her neck,*
> *her pearl skin, soft and ethereal.*

If any other man would have caught me reading, developing views, fostering opinions,
I would have been thought of as unwomanly, outspoken, fanatical,
but not to him. He's a fool- a jackass, if you will.
> *Her brilliance makes her beautiful.*
> *Wit dances from her cerebral lips*
> *and plays upon my soul like a bow to a violin's strings.*
> *Her melody is charming, an enchantress.*

The news isn't enthralling.
This town is nothing but a waste of social class and wealth.
I don't know what keeps me here. I don't know. Well... I might.
> *I know she feels trapped in her caged world of satin elegance.*
> *She won't say it, but I know she feels it-*
> *the warmth of a soul beyond her own,*
> *a light in her black slated world.*

He's been silent for too long.
I'll stand gracefully and
stroll into his corner.
> *She's alarming and provocative.*
> *I wasn't prepared for someone as eccentric as her, yet I want no one else.*
> *Her presence in front of me, with deep coffee eyes of hope, brings me the*
> *satisfaction of knowing I've won the battle within her.*

"Stop watching me you fool!"
I exclaim, with a gentle kiss.
I surrender my flag.
> *Finally.*

Damn it. I gave in.

Collectively

Poetry by Autumn Ladyga, Junior
Photo by Kate Smith, Senior

As thoughts race through my head,
I wander from memory to memory.
The words lost.
The love left alone.
Balls of paper on the floor.

Words escape me from time to time.
This time for instance:
I don't know what to say to tell you everything,
To tell you how my love for you is stronger than any machine,
To tell you that I get that butterfly feeling inside of me when I see you look at me.

I don't have the right descriptions to even compare to the reality of it.
My feelings aren't transferring collectively from heart to paper,
From mind to words,
From hopes to possibilities.
I write and write
And write and write,
But the balls of paper remain to collect upon my bedroom floor.

This is nonsense,
This feeling.
I'm whole, but empty.
I'm excited, but nervous.
I don't want to mess this up.

I need you to know how all of these feelings have been collecting.
Collectively, my love for you grows,
Yet with the few simple words that you just said,
It all changes.
All of my outlook is distorted
Into something else...

Something better.
I can now look into my own future.
I can make myself my own,
And you're just there now.
You're not who you used to be,
And I'm not who I used to be.
Our hearts are in different directions now,
A thorn not through them,
But just an arrow pointing to separate paths.

I will always love you,
A part of me will,
But I'm finally moving on.

Collectively,
I have my heart set on this now,
This feeling of becoming stronger.
Without you.

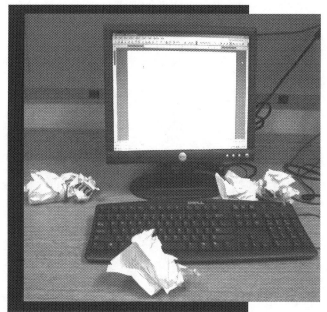

thequietplaces

There There is a place that I go when I simply need peace and quiet. This place is very special to me, and it is uniquely mine. No one else goes there, and no one bothers me there. My parents don't even know where it is and neither do my friends. It is all mine, and it is my sanctuary.

Prose by Kaitlin Miller, Senior

Photo by Kate Smith, Senior

I discovered it one day when I really wasn't paying attention. I was having a very difficult day, and I simply did not have the energy to direct Magic, my horse, so I let him have his head. He must have discovered it long before that day, but when I realized that we weren't in the pasture anymore and looked around, it was like opening my eyes for the first time. It was so beautiful, but I knew that we couldn't stay long. We returned home after a little while, and from that day on, I knew that I could go there whenever I needed some peace and quiet.

It is not easy to get to my sanctuary. The only way that I know of is by horseback. I suppose you could walk, but it's a good mile to a mile and a half

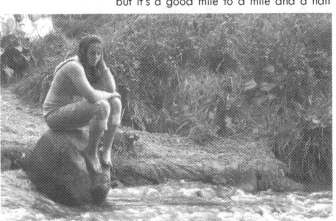

from my home. Every time I go, I saddle my gelding and grab some snacks (I'm usually there for most of a day), and off we go. The woods at the back of my pasture hide the path very well, but Magic and I know the way. Past the giant red oak, take a gentle turn to the right, between the two scotch pines and from there it's a straight shot all the way to the Yellow River.

There is a clearing that is completely natural. It is probably 20 feet wide, and maybe 12 feet in length. The clearing is wonderful. It is quiet and peaceful, with the sound of running water in the background. There is plenty of grass for Magic, and I can just relax. I don't have to worry about homework or practices. When I'm there, there are no such things as scholarships or proficiencies. I don't have to worry about a thing when I'm there, and it is like no other place in the world.

There is a pile of large rocks that overlooks the river. The river is surprisingly clear and cool. The current keeps the mosquitoes away, and the fish are fun to watch. The birds love to sing, and there is almost always something beautiful to observe. In the spring the flowers start to bloom and fill the air with their sweet scent. The grass is green and sweet smelling. There is a large tree stump in the center of the clearing, and I love to sit on it and read. I love every bit of it.

My sanctuary is all mine. I feel so much peace when I am there. It is the single thing that can overcome all of my emotions, and I look forward to spring because I know that I can start going there again. This place is my nature, and I wouldn't trade it for anything else in the world.

Silver

Poetry by Kelsey Piotrowicz, Senior
Photoshop by Karen Celmer, Senior

The silver lining of moonlight shimmers
on the dark abyss of the river.
The water ripples, and night becomes a sparkling wave,
an iridescent dime for a chance at time,
for your charcoal shadow to envelop me,
for the evening fog to drift over us and hide
the ring of sweet light on your finger.
With darkness still around, you won't leave.
Twinkling in the twilight, I can only see your eyes,
but I need no more;
for your sterling stare assures me that night still lingers,
though the sands continue to filter,
and you will not wander from the silver light of the moon.

Woman with Four Legs Marries

A spider.

Fiction by Kelsey Piotrowicz, Senior Scholastic Writing Silver Key Award

Oil by Jacob Kunnen, Senior

Have you ever watched one with its long, delicate legs gliding down its twinkling gossamer web? The spider's home, its life, is so fragile. With one swipe it could all be over. If you notice, spiders are also normally always alone; alone in their abandoned attics or untouched corners. When I was younger, my house was never clean. We had spiders in every nook of the house. I remember looking at them and seeing myself. Yes, having the four legs was an obvious similarity to a spider's eight, but that was just touching the surface. There was more, though. For so long I was a feeble being, always on the verge of tears, always lonely, always like those creatures.

To my mother, I was the accident- a one night stand surprise. My father was probably one of those tacky, balding men, who always seemed to sniff out my mom in the grocery store or the bar (those being the only two places she went besides K-Mart for work). My mom wasn't fond of her little present, especially since I wasn't the typical little girl. Four legs wasn't double the gift. Don't get me wrong, she loved me in her own way, but never as a mother should. I was the beautiful, little freak that my mom didn't know how to handle. After I was able to be on my own, she avoided her little mess as much as possible by drowning herself in relationship woes,

work, and bars. I never blamed her; I didn't know to. I lived my life in solitude, seeing my mother only when she needed to change into another animal print dress or reapply her blood red lipstick and sea blue eye shadow before leaving again. She would have been a beautiful woman if not for the disgusting life she led. In short, my childhood was a series of TV dinners, solitariness, and school.

My legs were never an issue for me, personally. When I looked in the mirror, I just saw two extra, ordinary looking legs. Never would it have occurred to me that they would be significant to other people because my legs weren't imperative to my

personality. I soon learned of my mistake. Elementary, middle, and high school were all a blur for me. It's human nature to block out negative life events. To be blunt, it was miserable. School was a whirlwind of good grades, bad lunches, dreadful people, and growing up. As one would expect, I was teased relentlessly. "Octopus Girl," that was my favorite name. Teenage boys can be so clever. I had a few friends throughout school, none important enough to remain close to. Teachers loved me, or probably, pitied me; I'm not sure which. My grades were excellent, which wasn't hard to do since I had no social life. If kids didn't hate me for

being weird, they hated me for being labeled the class pet. It's ironic that people can hate you just for being who you are. Regardless, I was a loner, hanging on to my frail thread of a life.

After high school, I followed the normal life steps: moved out of my mom's house and into my own, went to college, got a job as an accountant, and began to live on my own. I remained alone for awhile, until I met my neighbor, Gladdys. She was an older lady of about seventy-five. Despite her age and short, fragile stature, she was in her prime. Her silver tresses were always loosely, but neatly, pulled into a braided bun. Glasses were always perched at the tip of her nose. She dressed to the nines every day- classic but sweet pastel dresses and a pearl necklace were her usual choices. She approached me one afternoon for

sugar. I had just gotten home from work when she walked over to the gate of my house. "Hi, sweetie. I don't mean to interrupt. I'm Gladdys, your neighbor. Dear, I'm baking cookies for my grandson," she said. "Do you have some sugar I could borrow? I only need a cup more." She greeted me without once looking at my legs. It was a first.

"Um, I sure do. Let me go get it for you."

"Your name's Jenna right?"

I nodded in reply.

"Well, Jenna, just bring it over. The front door is open and you can just come right in and have some fresh lemonade and some cookies. I'd love the company." With sugar in hand I followed her orders and walked right into her house and into the kitchen. I spent the rest of the afternoon learning about Gladdys and

her life. Her husband had died three years previous. As a commander in the Marines, he had lost a leg during Vietnam. She was used to odd limbs. They'd been married for fifty-

seven years and had four children, eight grandchildren, and two great-grandchildren. Her life was like that of the Cleavers. I was astounded.

"Which grandson are you baking the cookies for?" I inquired.

"Simon. He's about thirty. I

know it's silly to make cookies for a grown man, but he loves them. Always has. He'd never ask for them now, of course, but I like to give him something. He brings me my meds every

Tuesday. He refuses money, so this is payment. He's a pharmacist, you know."

We repeated these conversational sessions every week. I loved talking to her. She was warm and amiable. Never did she turn me down for a dinner,

and she always invited me over for tea or coffee or lemonade. Kindness like hers spreads like a wild fire, burning through the long locked gate to my closed-off world. She was inspiring.

Ironically one Tuesday, she began talking to me about her pharmacist grandson again. We were sitting in the kitchen chatting over some spice cake and coffee. "You know, you would love my grandson."

"Well, I'm sure I would."

"Simon's a very kind man. Tall, dark, thin. Gorgeous really. And I'm not just saying that because I'm his grandma. He'd be an excellent boyfriend."

"Oh, well... I'm not really looking for anyone."

"Well, neither is he. I'm just saying you both are so sweet and precious. I'd just love to see you two together."

"Are you talking about me again, Grandma?" a man's voice said. I turned around to find the single most handsome man in my life. He had golden brown hair, short and clean cut. His face was chiseled into a square jaw with deep aqua eyes. He was in a green collared shirt and gray slacks.

"Hi, I'm Simon," he said with a smile. He reached his hand out to shake mine. I tried to get up to greet him, but miscalculated the placement of the table leg and my own legs and landed flat on my face. My head hit the linoleum with a loud *thunk*. Damn my four legs. Soon, sinewy hands grabbed my waist and pulled me upwards onto my feet.

"You sure took a spill there. You OK?" he asked.

"Oh Jenna! Are you all right?" Gladdys chimed in.

"Yeah. I'll be fine." I felt a little woosy and tottered a little. I was also extremely upset with myself.

"Simon, take her home. She lives right next door. Get an ice pack and put it on that bump."

"Yeah, sure, no problem. Come on, Jenna. We'll get you back." He held me up the whole way back to my house.

"You didn't have to do this, you know. I could have made it alone."

"I'm sure you could have, but I'll feel better knowing you got in safely."

"I sure made an ass of myself today."

"Nah," he laughed. "It was funny. Now I'm intrigued."

"Excuse me?"

"Do you honestly think it was coincidence that my grandma asked you over for cake at the exact same time she wanted her pills dropped off? I wasn't sure I'd like someone my grandmother picked for me again. Her intentions are good, but she's tried this before. Didn't end well the first time. She did good this time, though."

"So it was a set up?"

"Well... yeah."

"And you knew about the legs?"

"Yes, and I'll admit I didn't know what to think. But I guess I just figured I'd see for myself how I felt. They don't bother me though. They make you different, but in a good way."

"Oh, well... I don't know about that." I felt the bump on my head. We both erupted in laughter.

"Listen, since you are clearly not going to be up for a lot of action with that large bump on your head, how about I order out somewhere and bring it here tonight."

"Like a date?"

"Yeah."

"OK."

"OK. Well um, Chinese food then?"

"Sounds good. Sweet and sour chicken please. And don't forget the fortune cookie."

"You got it." He returned an hour later, and I had the best night of my life. He was charismatic. Simon had a spirit in him that hit me like a hurricane. It was like

- The F Words -

God, or something, had given me another chance at a life that I'd desired.

I always thought that books and movies ruined love. Normally, I scoffed at the romance section of Blockbuster or Barnes and Noble. They pegged love as being this immediate attraction, life altering. Never again could you live without the person. It was all a ploy. Life, nor love, could ever be like that. It was an impossible dream that manipulated the minds of people. That one night with Simon, though, changed my entire theory. It *was* possible that one person could captivate the attention of every fiber of my mind. It *was* possible life could be altered by just one person.

We were together for three years. I experienced life in a new way, and I clung to it for dear life. Every time I was with him, I felt alive, like life had flooded back from an empty spring that was inside of me.

The one thing I remember most of those three years is dancing. When I was younger, I always watched those old Gene Kelly movies, the ones on Turner Classic Movies like Singin' in the Rain and An American in Paris. I longed to dance like Gene and to have a partner like him. Simon is and was an excellent dancer. His mother is a dance teacher, so he had no other option but to learn. I had always feared dancing because of my legs, until Simon proved a confident partner could make anything possible. Within one month I learned to waltz and jitterbug. In effect, Simon taught me how to do much more than dance. He showed me how to live and fulfill my dreams, as corny as that all may sound. I can still hear "Moon River" playing softly as we glided across the floor....

He proposed on October 22, 2008, which is why I'm standing in the back of St. Anthony's Church, waiting to walk down the aisle. The church is decorated in cream colored orchids and lilies and roses-classic, but beautiful. The pews are seated with beautiful people all waiting for me, the bride. My mom actually showed up, too. She has a little less makeup on than normal, and her cheetah dress goes below her

Watercolor by Brooke Poeppel, Senior

knee for once. I know she tried. Gladdys is sitting in front, beaming with pride, for this was all her doing. Simon's sisters, Anita, Lana and Geogiana, are all buzzing bridesmaids, running around checking my hair and dress.

Kindness is a family trait.

As I stand waiting in the lobby eager to hear the sound of the music start, I see a spider on the wall. A small little creature on the wall, trickling down its lonely web. I no longer see myself in her. She is built for that life, not me. I am finally, somebody's someone. I am finally happy. The music's beginning. That's my cue.

Unsinkable Sisterhood

Poetry by Catrina Kroeger, Junior
Pen & Ink by Seth Baker, Junior

Did you feel the fear when the ship was hit,
The immense amount of screaming?

People jumping, babies crying,
The sound of the innocent dying.

Have you felt such sorrow
As you felt on that cold night

When all structure was hopeless,
No refuge in sight?

It felt like forever meant nothing at all
When the fast-flowing water was filling our hall.

We paid for first class and we ordered the best,
But who could've known this would be such a mess?

Who would've thought the unsinkable could sink?
They said it was huge, an iceberg, I think.

My contempt for our captain will never be gone.
We feel we can't cope; it's so hard to move on.

But we must paddle on now
As we're headed home.

We are off to England,
And we're both all alone.

We've both lost our beloved husbands,
But I know I have you.

Our sisterhood undying,
Our friendship stays true,

For you helped to save me
And keep me alive.

I know we can start over
And learn, again, how to thrive.

We have less than we've dealt with,
But love will help us get by.

- The F Words -

The Queen of My Heart

Poetry by Audrey Mahank, Senior
Pencil by Merissa Mills, Sophomore

She's lost. All that's left of her are these seemingly meaningless things.

But each means so much to me. The card, a queen. She was the queen of my heart.

The rose, the faint scent she always left behind. The marble because she was strong until the end.

The makeup because she never thought she looked perfect. That locket that she always wore.

It contains a picture of her smiling face right next to mine. It will forever be close to my heart.

Father's pocket watch, he always carried around. After he died, she never let it leave her sight.

The fruits to symbolize her passion, and the brass F that stands for Family

because family is the most important thing.

And finally, the mirror who tells us the fairest of them all: My mommy.

death comesforall

Fiction by Heather Helminger, Senior

Photo by Kayla Goforth, Senior

I worked in a nursing home on the corner of Edison and Grange: Ray's Assisted Living Facility. Sounds classy, eh? What can you do when you're desperate for money? The residents housed there were bipolar, senile, and just plain unpleasant. Getting up at five and going to work was always a drag. The only thing joyful during those long hours was Shirly. That woman sure did have spunk, and she definitely taught me a thing or two while I worked at Ray's.

Shirly was a plump lady who needed a wheelchair but refused to use one because she was "not handicapped." Boy, she was a pistol. A drunk Irishman who claimed to be her boyfriend would visit often. They would "do the deed," and everyone was sure to hear the commotion. As sickening as that event was, nobody dared to interfere or there would be hell to pay.

Creepy old men would always try to get Shirly's attention by bringing her lilies, chocolate, and other assortments of gifts. Nobody ever did get her attention except for the Irishman who reeked of heavy liquor. What she saw in him, I'll never know.

One day, I went to converse with her on my break. Shirly was in her room watching a segment on scuba divers on the Discovery Channel. She hardly even noticed that I had entered the room. I sat on the edge of her bed. Ironically enough, the smelly nursing home scent never could penetrate the unique aroma of Shirly's room. That room was a haven for me to escape the rancid smell and the crazy loons who wandered around.

"Hey, Shirly."

"What up, girl?"

"Oh, nothing, just thought I'd step in for a minute and see what you were doing."

"I'm just watching the 'ol boob tube."

Her eyes weren't as spunky and wild. She wasn't as talkative either. I sat there and watched her mindlessly gaze at the television. No more words passed between us, and sooner than I expected, it was time for me to return to work.

"Well, I'll uh, see you later then."

"Mhmm."

I crept out of her door feeling awkward. I couldn't remember a

- The F Words -

time that Shirly wasn't bubbling with conversation. Maybe something had happened. Why hadn't she confided this newfound dilemma with me? My mind raced for the rest of the day. When my shift finished, I wandered to Shirly's door and walked in.

"What's going on?" I demanded.

"Now, don't go getting all hot on me now."

"You didn't even talk to me on my break. I figured something had to have happened for you to stay quiet so long."

"Oh, it's nothing major. The doc just came in today and said my heart's failing and I don't have a lot of time."

"A lot of time for what Shirly?"

"To live."

The words swept over me like a tsunami. Death. Death was a prominent figure in my life. People from the nursing home would pass away, and for some reason the idea never struck me, that was until that day. The thought of her not being there was absurd.

"It will be okay, dear," she tried to reassure me. It was in vain.

"No, it won't. What will I do when you're gone? Who will help me keep my sanity? This can't be happening."

"There is a time for everything, and eventually, everything's fuse burns out, even the sun's."

This phrase made me angry. How could she be so calm? Tears welled up in my eyes, and I walked out the door and didn't say goodbye. That was something I will always regret. All that night I couldn't stop thinking about all that Shirly had taught me: "Don't let anyone hold you back." "Have self-confidence." "You only live once so live it well." The fact that Shirly was going to die

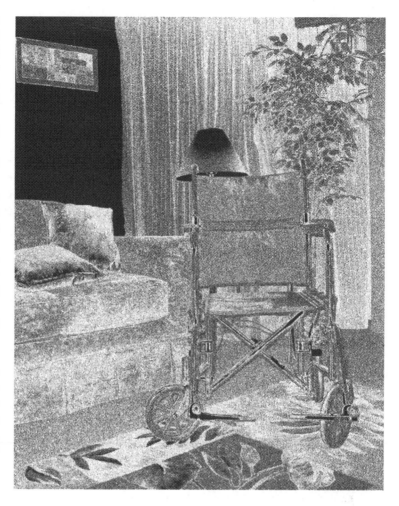

soon was too much for me to bear. I must have fallen asleep, because the next thing I knew, the alarm clock was going off. Groggily, I rolled out of bed and got ready for work. The ride to the nursing home was dull and mind-numbing. I had to talk to her and tell her how much I would miss her. I couldn't be angry because this situation was in nobody's control. An ambulance was at the front entrance. My heart stopped beating. Shirly. I parked the car as quickly as I could, and I ran to the building.

"What happened?"

"A resident had a heart attack. She passed away when the medics arrived."

"Who?" My nerves were on edge.

"Shirly Jones." At that moment everything stood still. The colors became gray, and my head felt light. For some reason I turned around and ran.

Her funeral was full of bright colors, no black. I felt at ease knowing Shirly had successfully made it to Heaven. Never will I forget her boisterous attitude and her gentle spirit. She flies in the wind and blows through my hair. One day I will see her again. Until then, I will save her a seat whenever I watch the Discovery Channel. Everything eventually burns out, even the sun.

Hazy Golden Dream

Poetry by Megan Snyder, Senior
Scholastic Writing Gold Key Award
Tempera by Anna Schmalzried, Sophomore

You stand there

in this hazy golden dream

wearing the yellow hoodie

I love to see you wear.

In my dream

you take my hand in yours

my delicate fingers fit

so perfectly in the spaces

of your strong hand.

I'm here

with my hopes spread out

like sand along the exquisite beach we walk on.

The ocean waves lap at our feet and

we move in silence, splashing in the low tide,

our jeans soaked to the knees in the salty spray.

To myself I think, *This boy is my sunlight.*

The fiery star of the day fades over the horizon

and I start to shiver.

You slip out of your yellow hoodie

and pull it over my head

to calm my trembling.

The moon and the stars show their bright selves above us.

"Make a wish," I whisper to you.

"I can't think of anything," you say.

A lone seagull screeches across the ink-blot sky.

"Fine. Don't make a wish. This right here is my wish anyways,"

whisper as I wake from this hazy golden dream.

- The F Words -

My Best Friend

In a near-empty room, two mattresses form the dominant furniture scene. The morning is quiet. Adolescent adornments litter the floor: clothes, a class ring, wallets, a pair of glasses, phones. There is near silence, but for the soft baritone of a voice, the voice that I cannot help but love to hear. Steam rises from a mug of green tea as a white square serves as the focal point. Simple: that's all it is and all it needs to be.

That's the beauty of our friendship. Excess words and senseless drama have no place. A

Prose by Jake Ladyga, Senior

Charcoal by Adam Kickbush, Sophomore

blue and grey striped jacket is a silent testament, a spontaneous link between those of like mind, for all their differences. Symbols may be wanting, but one stands above them all, the one that says it all: his face. His bright blue eyes, large cheesy smile, and still child-like face serves as the mask of the soul that I love so much. He is my brother, whose innocence I feel strangely protective of. A friendship forged in eternity, that may shift in shape, but whose essence remains whole and perfect.

White Satin

Poetry by Kelsey Piotrowicz, Senior
Photo of Kelsey's Grandmother Elizabeth Reed

You stand augustly dressed in
cascading white satin and lace.
An ancient picture of black and white, but pearl skin and rose lips
appear as clear as the April day it is.
Your beauty doesn't take much.
No jewelry or frills, just a veil and a dress- simplistic elegance.
The scent of fresh, white daisies dances around.
The swift wings of a hummingbird match the beating of your fluttering heart.
I wish I knew what thoughts your averted eyes hide.
Placid excitement waits, subdued upon your adolescent face; tender, graceful features not
much older than twenty years exude beauty beyond that of the flowers you clasp.
The silk singing song of future rings in your presence.
That was your day; if only you could be here when my bells chime-
to remember your life and to share in the beginning of mine.
But your spirit will be with me on my white satin day
to pacify and hold in my heart the secrets your picture holds.

Temptation

Poetry Renga by Kate Smith, Adam Novello, and Kayla Goforth

Pastel by Brooke Poeppel, Senior

Silky skin and satin lips,
Temptation lingers at my fingertips.
The sky is cloaked, we're without light;
Your heart is all I hear tonight.

I notice your scent most of all,
Like crisp, fresh air melodies on a late night fall.
The stars start to shine from above,
Revealing this passion that is our love.

Our bodies, souls, they're intertwined.
Words are whispered; you are mine.
I lead you away, showing instead,
That I'm more in love with things unsaid.

F E S T E R I N G

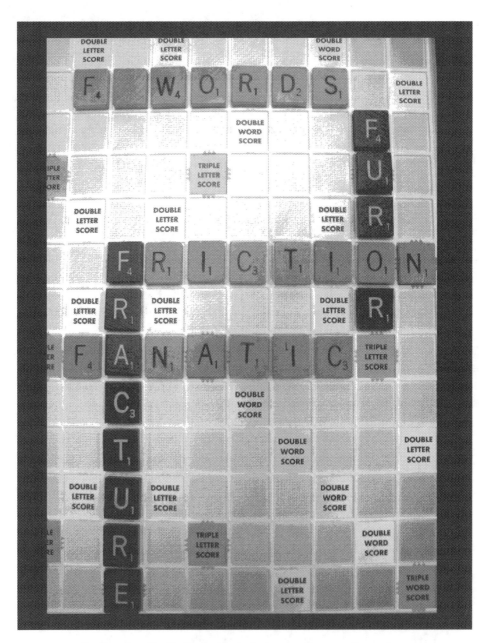

Feeling frenzied? **Festering** is just one of many F words
that can fill our minds with images of anger, pain, hate and rage. Follow our writers
and artists as they focus on the furious, feuding, fuming side of fisticuffs and faults.

- The F Words -

Like a Fire

*Poetry Renga by Mark Davis, Megan Beery,
Erik Frankiewicz, Lauren Kipper, and Mark Davis
Photo by Kayleigh McMichael, Senior*

It's like a fire,
the burning that no one wants
to feel. It takes emotions higher.
This is how I

rage, the embers in my mind
set fire to all those around me,
sending me on a war path of destruction.
I burn the bridges between us and in my fury,
 I grow

just like the fire, burning brighter.
I begin to feel the heat.
It surrounds all of me, fuels my actions
and gives reason to the madness,

spreading around, sowing destruction,
fear and hate.
I am a plague of unbearable anger.
It courses through my veins like blood

Burning, festering inside.
It's a burning that I could choose to hide,
but instead I turn to you and lash
out, leaving you for dead, in smoldering ash.

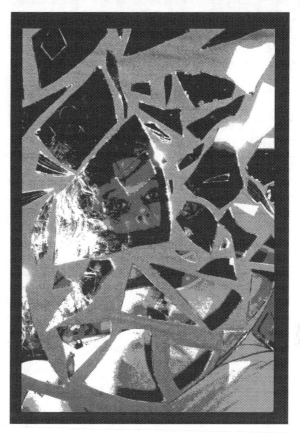

Endless Cycle

*Poetry Renga by Autumn Ladyga, Chantell Cooper,
Audrey Mahank, Kayla Goforth, and Breanna
Kretchmer*

I'm sick of this continuous cycle
of getting pushed around, smashed to the ground,
when you just keep on

saying the things that you always say
while never considering what it might do to me.
Could you just stop and see my feelings for once and

cease the yelling?
Just for once, please consider how it makes me feel.
I'd rather have

the truth than all of the lies.
I'm tired of these blood shot eyes,
so what can I do or say

to make this cycle go away,
to stop all the tears and shouting?
I wish you'd just listen and end the pouting.

MURDER
at the
CHUCK E. CHEESE

Fiction by Jessica Verkler, Senior
Oil by Chloe Bugajski, Senior

"Binky, are you going home already?" I asked my fellow clown. He looked at me as he took off his clown shoes. He's been in the clown business for quite awhile.

Binky has appeared at more birthday parties than any other clown here. Binky is a legend.

"Yeah, I'm beat. I can't take being around these brats anymore. I only do it because the pay is good for the little work I have to do."

I had to agree. Sometimes I wondered why I did this job. I loved being a clown, but it was tiresome. Screaming kids could get on your nerves to no end. Plus, I had other problems to worry about. Specifically, my wife. She'd been acting really weird lately. I don't mean just moody; I was used to that. She was acting flat-out weird. Claire was jumpy, quiet, and defensive, not her usual qualities. Normally, I wouldn't worry, but I have a killer gut instinct, and I know when something isn't right. Once when I was a kid, I was walking home from school and something told me I should walk faster. I don't know why, but suddenly I knew I should just run. So I did, and when I got home, I found my mom on the floor. She had had a heart attack. Luckily, I had

gotten home soon enough to call the ambulance, so she lived. Ever since then, I knew I had a gift.

Well, my gift was going crazy. I loved my wife so much, but I had a feeling that something was going on. I knew that she hated my career as a clown, her having a phobia of clowns and all, but I thought our love was strong enough to withstand that. Lately, she just seemed distant. She didn't seem interested when I talked to her anymore. She didn't want to do the things we used to do, like go for walks and watch *The Sopranos*. As I walked out to my car, I decided that tonight I would ask her what was going on. I left earlier than normal, so it would give me plenty of time to prepare. If only I could have seen what was going to happen later that night, I wouldn't have gone home. I would have stayed in town...

I pulled into the driveway and saw my wife's Mazda already parked there. *That's strange,* I thought to myself, *I always beat her home.* Her job as a pet groomer kept

her at work until 8:00 usually. I got out and walked to the door. It was unlocked. We always locked the door when we were home. I pushed it open and went into the living room.

"This is too weird," I muttered. "What is going on?"

I started to fear the worst. What if something happened to Claire? As I walked towards the kitchen, I heard a noise down the hall. I stopped and listened...*what was that?* Slowly, I started creeping towards the sound. I heard it again, and it was....a laugh. The faint sound of my wife's laugh. A sound I hadn't heard in forever. It was coming from our bedroom. I pushed the door open and walked inside...

I stopped dead in my tracks. There was my wife, my Claire, holding on to another guy. They were sitting on the floor. Empty margarita glasses littered the ground, accompanied by an overturned salt shaker. An unused coconut sat at their feet. My wife and this other man, who was wearing

- The F Words -

a sweaty soccer jersey, stared at me in disbelief. I felt like everything had shut off. I couldn't believe what was going on. *It's not real, it's not real* I told myself. My brain felt like it was going to short circuit soon...

Suddenly, an anger came

over me I'd never felt before, a type of anger I'd never thought a person could feel. I stood there, in this ridiculous clown outfit, watching my wife choose the guy I knew she'd always wanted me to be. I never felt like I was worthy of her, yet for some reason she married me. She told me she loved me. Even though my career embarrassed her and she hated it, she stuck by me and said it was OK. Yet all this time, it had been a lie. I had never been

good enough for her. I was an embarrassment. I could see her at work, complaining to her friends about me. I could see her eying this man, wishing I was more like him. And finally, I could see her choosing him over me, because she just couldn't stand me anymore. I didn't feel myself move. I just saw my hand reach out and grab the coconut. I saw myself raise it up and bring it down on my wife's head as she looked at me in horror. I couldn't stop myself, even though I wanted to. *Was I going to stand here, in this stupid clown outfit, and let my wife cheat on me? No, I wasn't.* Once I was done, I realized it only took me 15 seconds to kill my wife. I never thought I was capable of such a thing. Yet I felt no emotions. I was completely numb inside. Then I turned to the guy who ruined my life...

"What's your name?" I asked him, still holding the coconut, which was now covered in blood.

"Eduardo." His voice

shook. "You just killed your wife you psycho! With a coconut!"

"So now I'm the bad guy? If you hadn't been cheating with her, I wouldn't have had a reason to kill her." What were these words spewing from my mouth? They weren't me at all.

"Please, don't hurt me. I didn't mean anything by it." He started to stand.

"You mean you didn't realize how much pain it would cause me when I found out?"

"I just didn't think about it. I'm sorry. Claire said she was going to tell you."

"She never told me. Do you really think that would have made it better?"

"I don't know. Maybe..."

He suddenly charged at me like he was in a soccer game. He pushed past me, and I staggered backward. I dropped the coconut and followed him. He was already out the front door, but I still pursued. My clown shoes made it difficult to follow, but I didn't slow down. I ran at a steady pace, my eyes on my goal. He saw me behind him and ran down the sidewalk, then took a left on Lincoln Street. I continued running after him. He reached the end of the block and turned down a dark alley. I was lagging behind, but I didn't stop. I came to the opening of the alley and saw him go in through a back door. I caught up and jerked the door open. Then I stepped inside, ready to finish what I started...

At first I didn't recognize where I was, but then I realized it was the local Chuck E. Cheese. I was standing in the kitchen where they make their disgusting pizzas. I saw Eduardo go around a corner and into the play area. I followed him.

He wasn't going to get away from me! I realized that I would need something to defend myself with, in case he wanted to attack me. A random lamp was sitting on the counter, so I picked it up and walked into the play area.

It was quite dark inside, but I could still see well enough. I was sweating terribly, and my clown paint was running into my eyes. Every sense in my body tingled. I listened for the slightest sounds. I looked for any movement. I even tried to sniff him out. Suddenly, I saw something move out of the corner of my eye. I turned and saw Eduardo standing there; he had been hiding behind one of the basketball hoops. He started running, and I chased after him, swinging my lamp. We ran through the arcade and into the dining area. I knew my way around this place. I'd been here many times for birthday parties. I knew every nook and cranny of this Chuck E. Cheese. He couldn't hide from me. He ran back into the play room and stopped at a dead end. There was only one way out, and I was blocking the exit. I stepped forward, smacking the lamp into my hand. He backed into a chair and fell over. I decided that I would make this quick. These clown shoes were killing me, and I was starting to get tired...

After I finished, I needed a place to hide the body. I couldn't risk taking him outside. I looked around. *Where in a Chuck E. Cheese could I hide a body?* Then it hit me. The ball pit is like 5 feet deep, and it never gets cleaned. They won't find his body for months. I picked him up and threw him in the ball pit. I moved the plastic balls around until he was swallowed up and buried. Then I picked up my lamp and left.

Once outside, I threw the lamp in a dumpster and started walking. I didn't even realize where I was going, but I found myself back at my house. I couldn't believe how the night unfolded. I killed my wife and her lover. I said the words out loud to myself, but I didn't feel anything. I didn't feel remorse. Was something wrong with me? I loved my wife. And yet, I still didn't feel

Oil by Alysha Six, Senior

anything. I felt other emotions, but not remorse. I didn't realize it, but a change had occurred in me. A very dark change...

Standing in the fading light, I suddenly realized that I had to leave. I couldn't possibly stay there. Looking at the blood on my size 24 shoes, I ran into the house and grabbed a few things. I cleaned out the money jar Claire had started. I went out to the garage to get my

car. As I was backing out, I noticed something. It was the red tricycle my wife had been saving in case we ever had kids. For whatever reason, I decided I needed to take it. I parked the car, grabbed it, and threw it in the trunk. Then I backed out of the drive and left. I didn't even look back; I just keep driving. The farther I drove, the happier I felt. I started laughing to myself.

What is wrong with me? I wondered. But I couldn't stop. I felt like something inside me had been freed. I started thinking about games, and suddenly I wanted to play one.

"Let's play a game," I muttered. I don't know where it came from, but I couldn't get that phrase out of my head. I laughed at myself and my crazy thoughts as I drove off into the night, forever lost, never to return again...

- The F Words -

Sands of Change

Poetry by Adam Kickbush, Sophomore
Colored Pencil by Dylan Krebs, Senior

I stand alone in the heat of the sun,
No water or food to keep me alive.
I try to find hope but grasp none.
My energy fades and I lose my drive.

The winds pick up and I shield my eyes.
The sun becomes shrouded by a mass of sand.
I call out in pain but no one can hear my cries.
The stinging begins on my hand.

It moves to my arm and to all exposed skin.
The whirlwind pummels me still.
I fall to my knees as the world starts to spin,
As the sand prepares for the kill.

From whence It came I do not know,
And so swift it was a wonder.
It had no sooner beaten me low,
Than it was rent asunder.

There is peace again; am I alive?
I feel no pain to tell me so.
Reluctantly, I open an eye
And expected not what I now bestow.

A picturesque paradise envelops me.
A crystal waterfall roars.
My movements are free and easy,
My spirit soars.

I see my skin, so soft and new.
It nearly shines in the gentle sun.
The battle I was forced into,
I most surely have won.

The transformation's pain was a necessity,
And I know through the trial of the sand
And through all of my sadness and pity,
I have become a new man.

Blue

Poetry by Megan Beery, Junior
Scholastic Writing Certificate of Merit Award
Oil by Brooke Poeppel, Senior

Soul raider
but so much more,
I'm not the girl next door.
Sail the seven seas,
go wherever I please,
blown by a southern breeze.
I'm Blue.

Navigate by the stars all night.
There's no reason for your fright.
Night Owl will save you from my bite.
Your cry is my delight.

Live with the stars in your eyes.
This Sagittarius will be your demise.
I did it to Fyrefly, so when you're next, it's no surprise,
I'll break you with my lies.

I'll be your little muse,
a goddess in blue shoes,
and I'll write you love notes until you lose
your mind; you missed all the clues.

You'd do best to leave me alone.
I'm like no one else you've ever known.
My blonde hair and blue eyes won't condone,
I'll draw you in with only my voice and its sultry tone.

In my dark blue eyes you'll find bliss.
Every moment away I know you'll miss
that drunken feeling you get when we kiss.
There'll be no end to this.

Cruel irony has its grip on me,
given me the one I can't deny. He
has piercing silver eyes and says forever we
will be. To my heart has he the key.

Everything is more intense
than before; nothing makes sense.
He's there for me, and around us he builds a fence
to keep out the world that makes me so tense.

My friend, no matter what I say,
Night Owl will be there anyway,
and when down to sleep I lay,
I know he'll keep the wolves at bay.

Clean, clear, and cool,
I'll use you like a tool,
lead you to the dark pool
and make of you a fool.

This is not some silly cliché
of all the things I'll never say.
It's not a poem to describe how I feel today,
but a story of a girl who could go all the way.

This is the story of my life.
Sometimes there is strife,
and I've been stabbed in the back with a knife, yet
I wouldn't trade it for anything, because it's my life.

I'm a soul raider
as you now know.
I'm the one who dealt the blow
that brought you to your knees
and made your heart freeze
in a move as graceful as the dance of the wind in the trees,
I'm Blue.

LOST CHILDHOOD

Prose by Hope Kildow, Senior
Photo by Kayleigh McMichael, Senior

There once was a little girl who had a mother and father who loved her. She had an older brother and sister and a true family. I bet you thought this was going to be a fairytale, right? Well, if you thought that, you would be horribly mistaken. The terror of the little girl's life didn't set in until the little girl was about five years old.

Every kid dreams of a happy family, lots of toys, a nice house, and loving parents. This particular little girl dreamed of hiding places, Mom never coming home, and freedom from Hell. Is that the way every five year old around the world lives? That was what this little girl thought. How was she to know that parents weren't supposed to hit their children or go on massive, random rampages all the time? For her, life was go to school, come home and clean, and hope that she did a good enough job to eat that night. The desire to play was always burning, but the desire to survive was burning brighter still.

You hear about the big cases of child abuse where the child is dead or beaten so badly that he or she is almost dead, but you don't hear about the "not-so-important" cases that could be right next door. In this case, nobody knew about the abuse until a friend was allowed to spend the night for the first and last time. She told the authorities what she saw while sleeping over, and the three children were taken from their home. No need to detail what happened because it was a bit too gruesome. Thanks to that certain friend, the children were safe from their mother's evil grasp.

This little girl remembers the first slap, the first punch, the first time eating soap for no reason. The one thing she can't remember is when she was ever a child at all. She was always being pushed to work and clean and not cry around strangers. She was born to keep quiet from the world and do her mother's bidding. This little girl didn't have a childhood until she was around seven; she wasn't able to be a child. She was a slave in her own house, and no one knew a thing.

This little girl's name was Stephanie Rozelle Jenkins. She changed her name when she was adopted. On January 26, 2001, Stephanie Rozelle Jenkins became Hope Rozelle Kildow. That little girl was me. I am now determined to never turn out as my biological mother was. I have overcome my past and am on to the future. My childhood never existed, and my adulthood is coming fast. Thanks to my biological mother, I lost my past and thanks to my parents now, I have a future.

Terror at the age of five is scary enough without it coming from your own family. Not having a childhood is a terrible way to be a child. Every child deserves a childhood and time to play with friends. Take it from a person who knows; childhood is supposed to beautiful and innocent. Try to keep it that way.

Wrenched Feelings

Poetry by Chelsea Schortgen, Junior
Photo by Kate Smith, Senior

Peaceful pier, the sun is setting. I turn
on the radio and lights. The garage
is filled with only the sound of the Chevelle.
Then there's yelling. I turn and my only
terror is there. He throws
words and tools.

The middle of the day. I look out
across Lake Michigan as the Ferris
wheel goes round and round.
The pier is filled with laughs and smiles.
Boats are floating on the water.
There is nothing more than
peace and happiness.

It is dark. The mess he left
behind brings tears. The music
has stopped. I clean up the mess,
shut out the lights and walk up to
the house, and he acts
as if nothing happened.

Inside Me

Poetry by Jacob Hoyt, Junior
Pencil by James Bowen, Senior

Inside my mind everything is messed up,
From seeing my mother's neck cut
To everyone not accepting me.
If only they could see
The image burned into my brain.
All I see are the blood stains.
My mind is forever crying
While my soul is dying,
Hoping to be held by her again,
So I would never cry again.
But that won't happen for a long time,
So I sit here waiting for my clock's chime.
I can only hope for a higher power,
So I can bring my mother flowers
And embrace her in my arms,
Hopefully keeping her from harm.

Inside my soul demons reside,
And I can't run and hide.
They are clawing at my skin,
Luring me to the unforgivable sin.
Suicide is in my eyes
While everyone I love dies.
I want to be myself,
Put my personality on a shelf
And never speak another word,
But that would be absurd.
My bloodline is my pride.
I have my family by my side
To direct me through the flames
And keep me away from chains.

- The F Words -

Within the Camp

Poetry by Dan Meade, Senior
Tempera by Jacob Kunnen, Senior

Through the conflagration and pollution,
The flames burn high, the screams are real.
This was Hitler's Final Solution,
What have you done to be in this ordeal?

The figure of a shadow watches the incandescence
On the left, hunched over with sorrow in his stance,
Mere skin and bones behind a fence,
While at the camp, he knew that he had no chance.

Lifeless carcasses on the ground, the scent of death in the air,
The horrid smog rises up as Satan's face draws near.
Appalled at the sight, workers stand there,
Empty looks on their faces, as the smoke obscured all their fear.

The soldiers survey, they seem to be in hell,
You have done nothing, yet they don't care.
Why would they cast, upon you, this wretched spell
While they starve you and cut off all of your hair.

I wonder why those repulsive actions took place,
And what was going on in Hitler's mind,
In those fateful days, we now call a disgrace
As the flames crawled high killing mankind.

I sit here looking at this picture of death,
While flames run wild in front of you.
You stand there with Grace, holding your breath,
While you ask for God to save the Jews.

(DEADLY) Assumptions

Fiction by Kayleigh McMichael, Senior

Photo by Kate Jenkins, Senior

I wished on a dandelion for my husband to die. Some call that heartless. A joke. Wrong. I call it my better judgment.

I found a scrap diary-starter page nestled within his late-night, bedside copy of some pulp fiction on the wintry evening of October 4th of '76. We'd become the "tired couple," I suppose, the less rowdy or adventurous. The small lamps lighting our nightstands and current issue of *Time* or *TV Guide* or some turn-of-the-century, hopscotch novel. We each chose these to replace the word "goodnight" with, before the lights burned out with a *click* under the tips of our fingers. I guessed we'd go on this way. "Guessed" seems appropriate to say, given we never cared to discuss the "fire" that burnt out, the one we used to share. "Assumed" would mean that I felt somewhat certain. Considering I ended up on this side of the room, "assumed" doesn't fit here. I guessed.

The creased paper slipped out of that book as I hardly shuffled through it, nervously trying to find answers to such an emotionless man, a "shell." I found his chicken-scratch print carved across that paper as if the words were in a hurry to be erased or blotted out with more ink.

"I go to work every morning, hoping she'll say 'I quit'. This would be easier for me, for Emily." His handwriting was impatient, marking my name down in some tone of sarcasm. I refolded the paper at its crease and slammed it back into the novel. I sat on his side of the bed that we sort of shared, my hands clasping one another over the book that laid in my trembling lap. I mindlessly rubbed the center knuckle of my left index finger with the thumb and middle finger of my right hand, scared to read what I already knew. My hands unfolded and fluttered quickly through pages to the spot marked with his scattered thoughts, confessions. I let the paper fall open again, gazing, searching for the next words.

*"My Emily. I hope she forgives me. Someday, she will. When she has let the truth die, hopefully before I do. And I will make it up to her. But for now, Rose. I hate seeing her everyday, to feel guilty everyday. Maybe I could have her dismissed, just so I give her up. I don't know why I write this down, I'll never do it. I need her too much, **my** Rose."*

I read the last two words aloud to myself, letting them break in my throat. I paused on them, my eyes rereading her name over and over in his possessive script: *my* Rose. I bit my lip and hugged the paper to my chest, letting the crumpling noise it made fill my head while the rest of me searched for some sense of security. I put the book back in its place on the nightstand that some how felt so distant now. There wasn't any need to keep the paper. It had already buried itself under my skin. Besides, maybe he'd need to write more about *my* Rose later. I breathed through my nose, the air giving an almost grinding sensation as it passed through and filled me.

* * * *

"Are you sure you're all right?" he asked me time and time again. We'd gone over this already, too many times; it

was nearing hour two and he hadn't dropped it. I guess I didn't really want him to, in a way. Each time he asked, I let myself get closer to hating him. Maybe that was all I needed right now.

"Yea, just fine— listen, Ally across the street asked about some legal help. She's got a mess on her hands, and someone had referred her to a Rosemary—." He stared at me, no interest in his eyes. His mouth flattened into a straight line, as it always did when he was tired or bored. I was going to have to carry this entire conversation.

"Someone at your firm. Ally couldn't think of her last name."

"There's a Rosemary Banks at the firm. She keeps the books though, mostly. Running errands from time-to-time. She couldn't do much for Ally if it's legal help she's looking for." He still seemed uninterested.

"Oh, well, Ally's having trouble with her accountant," I quickly lied. "She needs some information to maybe straighten it out. You think maybe Rosemary—" I trailed off, realizing I had grown too eager for a calm conversation such as this one. Normally, my neighbors' problems weren't much of a concern to me, so I tried to keep this very casual, not wanting him to call my bluff. My lips had parted and strained to one side, showing a glimpse of both my bottom and top teeth. My fingers hardly interlocked with one another at the fingertips. I allowed my knuckles to relax into a more rounded form, hoping to lose the tension in them that was quite visible, even to Greg who didn't notice much of anything—or just much of me. It was funny how I'd quickly realized this, just from reading his stupid journal entry on that stupid piece of off-white paper.

I could feel my knees begin to tremble as he stirred his coffee, not facing me, the long, shiny spoon clanking coldly against the sides of his cup. I watched the steam rise up from the dark liquid and imagined it reaching up enough to touch his face. Would he notice? What if I had

touched his face? Would he feel anything at all?

* * * *

I remembered these thoughts vividly, pulsing through the aging muscles of my body, tucked in somewhat near the tomb of repulsive guilt— the guilt I feel now. A fiery guilt not completely painful

but savage. I saw him across this room so smothered with the scent of new leather and shoe polish. He stared right back at me, nothing left in his eyes, no thought— not that there ever was when he looked at me. The judge pounded his gravel loudly to bring the court to order. A moment of hysteria caused by yet another presentation of stomach-churning evidence.

A slight smile tugged at the left side of my mouth as my right thumb and middle finger moved slyly over the center knuckle of my right index finger.

The hush in the room felt numb in my ears compared to Rose's cherry-spiked shrill off in the distance of my thoughts. Those thoughts slipped momentarily to Ally from across the street; had she heard of the quick lie I used her for, the lie I fed Ben the day I decided to speak to Rose? I hoped not. Then my thought was interrupted when I met the judge's dark-edged gaze. My smirk began to pull up higher on my face this time. The judge quickly refocused, and I let my eyes shift back to Greg, who was still hollow and returning my stare once again. I don't know that he ever looked away from me. I wouldn't have noticed, with the throbbing in my chest accompanying the

Photo by Kate Jenkins, Senior

thrill this scene gave me— to be on this side of the room from him, still tasting the reluctance in his thoughts, was something I savored.

"...finds you guilty of the murder of Miss Rosemary G. Banks." The words broke through my translucent thoughts, once again, and my stomach slammed into my spine. I expected this verdict, plotted it, in fact. I imagined my face would be passive with my life starting over completely while his would be blanketed with confusion and innocent redemption. His life would be a dead end. I had toyed with this idea to its fullest potential, pleasure reigning over it entirely. But this reality, this was different. My better judgment? Maybe at first. I guess I didn't let myself believe in Greg's

pleas. I remember him telling me about it, the "guidance" *his* Rose had been giving him, the "advice." I remember the dreams he'd have, narrating them in his sleep. They were awful. Guidance. He thought he needed help. It became clearer to me as everyone on the benches around me began to stir about the room; I was wrong. That girl was counseling him, while I was bitter about a "mistress" who never existed.

My blood flowed thicker in my body, pushing its way through my narrow, stringy veins. Rosemary Grace Banks never slept with my husband. He was ill, mentally sick. So here I was, watching him being escorted out the door I was meant to walk through. She was innocent, an innocent life...*that I took.* Greg was paler than I'd ever seen him, the white sticking to his empty face. His *innocent* face. The pit of my stomach screamed, silently. I bit my lip and clutched my hands to my chest, searching for that same sense of security.

* * * *

I slid my teeth over one another, side-to-side, reliving the memory through my own impatient writing as I sat on my side of the bed we almost shared. He has been in prison for twenty-three years because of what *I* did. Fifty-eight more to go. I let the room spin until it crashed into me. I picked the pen up again, scribbling faster:

I look through our pictures everyday, hoping they'll explain why I did it.
I hate seeing these pictures everyday, feeling the guilt ignite.
I'm sorry. I'm sorry.
*I love you, **my** Greg.*

I creased the paper and slid it back into the withered book. I placed it on the nightstand next to me. I guess I hoped maybe he'd find it, someday. "Guess" seems appropriate to say. "Assumed" would mean I was somewhat certain. Considering he's serving just over one lifetime for *me*, "assumed" doesn't fit here. I guessed.

- The F Words -

Drowning

Poetry by Megan Snyder, Senior
Marker by Ashley Navilliat, Senior

The inky darkness of the sky
reflects my hopeless heart.
That great expanse of black
envelopes my senses,
dulls the pain,
blocks the harsh reality from my view.
The dark water of despair
sucks me under,
drags the ragged breath from my
torn and bloody chest.
Against all thoughts of silent peace,
I struggle for the surface,
fight the currents that demand
to haul me to the bottom.
My head breaches the cold water.
I can barely make you out,
standing on the farthest shore from me.
My lungs fill as I plunge down again,
willing the silence and the blackness
to take me with them.

One Word

Poetry by Ciara Kerckhove, Freshman
Tempera by Kelsi Valdez, Senior

One Word
That's all it takes
To never forget
To let the tears of pain fall silently
To hurt a child's fragile ego
To be "sick" often and without reason

One word
That leaves a pillow tearstained and soggy
That leaves hope hidden by shadows
That hurts more than any physical harm could
That is worth a million tears
That can kill youthful dreams
That darkens once bright days

This from child to child is passed without thought
But never is forgotten
The day it was passed to you

- The F Words -

Too BIG

Prose by Alyssa Wiegand, Senior
Photo by Jessica Figueroa, Senior

"We don't sell your size here," said the sales lady. I looked at her, that if- looks-could-kill-you'd-be-dead kind of look. The bra section was a place full of bright colors and muted neutrals, a place where few men ever go and a woman can almost always find her size. Well, not here apparently. I really wanted to ask her what my size really was, but I held my tongue knowing I would probably hit her had I spoken my mind.

I was just looking at the sales rack, which not only had cute bras, it also had a wide range of sizes as well. According to her though, my size had apparently fallen off the face of the planet or had been stolen by monkeys. The audacity of people amazes me.

This was my first blatant look at size discrimination. If you've never been there, you'd never understand that piercing feeling in your chest or feel that rise of color in your cheeks. Just knowing that you are fat enough that a sales lady has the nerve to tell you that they don't sell your size with just one look at your rotund physique can be devastating. I suppose she didn't realize how her statement came out, or maybe she had intended to hurt me. I'll never know. What I do know is that that day cut my self-esteem down more than any snide remark at school, any giggle, or any whisper. I really wanted to fire back a nasty comment or tell her manager, but I smiled and left her there.

That day I chose to turn the other cheek; she had already slapped me with her words. I figured she might as well get the other cheek while she was at it. I'll never forget those few words, nor do I look at the cute bras anymore. That was an awful feeling, but now I know what a choice of words can do to a person, so I choose mine wisely. I also avoid sales ladies, but that's beside the point.

I RUN INTO WALLS

Fiction by Megan Beery, Junior
Photo by Chloe Bugajski, Senior

Peace. I stare into the darkness of my closed eyelids as I push the end of the syringe down. Pulling out the needle, I cast it away. I hear it hit the back of the door like a dart as I fall backwards onto my pillow top mattress. Exhaling quietly, I tune out the low hum of the 42" in the living room. Fyre must be watching some sort of "how it's made" type of show or he'd be in here with me. A scene crosses my mind's eye, a silent memory from long ago. Remote islands are hard to come by, but somehow my parents acquired one, and it became our summer home. My sister and I used to wrestle on the beach every afternoon. We'd get so covered in sand that the only option was to jump into the ocean to rinse off. My father detested having sand in the house. It was simply not allowed. More often than not, we ended up throwing each other into the surf rather than enter it of our own accord.

My kid sister and I never quite got along the way that sisters should. We never fought over whose clothes were better, whose boyfriend was the most devoted or who had the prettier face. Hatred was never a word that was used to describe our relationship, as even at our worst, we always loved one another. Yet the underlying fact was that the reason we never fought over such trivialities was because the answer was obvious. I chose the more stylish clothing, my boyfriend was the most devoted and I had the face of a model. My sister was simply subnormal in comparison with the rest of my family, but we always loved her for who she was.

My happy memory left as the high began to come on. Fyre turned off the television, and I could hear him searching the condo for me. Finally, he opened the door and saw me lying on our bed. His baritone voice sounded concerned as he tenderly whispered my name. He thought that I had passed out. I answered him, telling him that I was fine and that I had left him some of the precious liquid. Fyre sat next to me and took my hand in his.

"You know that I prefer not to indulge when you do. If you get hurt, I would not be able to help you," he reminded me.

Tugging at my hand gingerly, he coaxed me onto his lap as he reclined against our wrought iron headboard. Opening my eyes, I saw what I did every time I shot up. I can see through the walls, and I am quite certain that I can walk through them as well. The air looked heavy as it settled to the floor. It appeared to be heavy enough to support me, and I wished to test this theory. I had tried to walk on it once, but Fyre found me standing on a bridge, straddling the rail guard. I had been trying to figure out why I couldn't put my foot down on the air over the ravine. He never lets me get high alone now; he blames himself for

- The F Words -

my "almost" death. My idea makes sense now though, because the air seems so sturdy. I tried to pull out of his hold, to see if I could walk on the air. This time I would only try it from the edge of the bed. Fyre's arms tightened around me as he buried his face in the hair at the base of my neck. He pressed his lips against my neck and inhaled my starlit scent.

"Be still, love. Just let me hold you," he murmured, careful to keep quiet. He was unwilling to break the intimate mood, and I didn't mind. He smelled like warmth, and his skin was soft against mine. I leaned back against him as he whispered my name. It sounded so good coming from his lips. It sounded like I was still the good child, the one who had the most potential to succeed. He made me sound like I was the person that I was born to be, but no matter what Fyre made me sound like, I was an addict, a disappointment. Someone who fell from a great height, never to return to the glory that I once held. Yet I was unlike all the others who had fallen from their pedestals among the stars, because I hadn't fallen. Quite to the contrary, I leapt head first, intending to go past the point of no return. I had done everything that I'd intended to accomplish, too. My first step was hooking up with Fyre, and seeing as I am living in his condo on the West Coast right now, I'd say that I did that fairly completely. That's not to say that Fyre was simply part of a plan, or that he brought me down. Fyrefly is the center of my universe, and he is everything that is positive in my life.

My sister, however, rose above what everyone believed her to be. She now ran her own business, was married to her high school sweetheart and had an infant daughter. Her business was doing well, and she had everything that she could ever want. She loved animals, and was close to owning her own petting- zoo-sized menagerie. My sister groomed pets for a living, so she was constantly coming in contact with the latest pet sale ads. More than that, she

had a problem with saying 'no' to cute cuddly creatures that contained big, beautiful brown Bambi eyes. I was just the opposite; I owned no pets, wanted no children and had no steady job. Fyre was a business manager at a company that worked with computers, and he brought in more than enough money for me to stay home. I enjoyed creating art; many of my works are now displayed about the condo. Quite a few pieces of mine were sold and now adorned the

homes of others.

I became angry with my sister for growing into her perfection just when I had abandoned mine. It was as if she had been there all along, just waiting to pick up the slack when I finally left. Hateful vapors sunk into my mood as I glared at the empty space on the bedroom wall. Fyre let go of his resolve to contain me. He let me get off the bed and warned me not to kill myself if I went out. I knew that he would follow me if I went out; he always wanted to protect me. At the same time, he would never hold me against my will, no matter how warped that will was at the time. Sliding off of the bed, I stood and walked over the air to the wall next to the door. I walked through the wall without using the door. That's just what I do; I walk through walls. Moving through the dry wall and lumber, I made a sharp turn and began to descend the stairs. Going into the living room where Fyre had previously been watching TV, I saw a picture of my family where it sat on

an end table. Crossing the room, I picked up the picture framed in a cheap golden band. Gazing into my own photographed eyes, I thought about when it had been taken, two years ago. It was before I had decided to leave college and run away with Fyre. I had been so fed up with the way that my family continuously pushed me on to greater heights, bigger gold medals and faster racing times. It seemed as though nothing I ever did was good enough for them. I could have always done better. I chuckled slightly to myself. I had used the term "run away" quiet loosely in this context, as I hadn't gone very far away. Little known to my family, I was only about a half hour away from my sister's house, and forty- five minutes away from my parents' winter home.

Sinking into a kneeling position, I sat on the floor and stared continuously into the photo, into my eyes. It was unnerving, like I was seeing myself in another life. Perhaps for all intents and purposes, I was. Raising the frame above my head, I brought it down on the plush carpeting and shattered the glass. Slipping the shiny paper out of its frame, I tore myself out of it, tore myself away from my once happy family. The family that was surely happier without me. I threw the photo of me to the floor, where it landed amongst the shattered glass. Still holding the glossy photo paper of my family in my hand, I stared in fascination as the glass shredded the paper me. I screamed as lacerations covered my flesh. I dropped the picture of my family to the floor and fell beside it. My blood covered the glossy paper, and gruesome images rose from it. My mother and sister stood before me, covered in my blood. They began saying that they were sorry and that they missed me, that they never meant to push me until I broke. My father stayed flat on the page, no blood would dampen his image. He told me that he'd always been proud of me, and that he hoped that I was happy with Fyrefly. I began to let my tears fall as I lay on the crimson covered carpet. My skin had been shredded identically

to that of the picture of me. But I knew that they were just fictions of the drug. My family didn't miss me. They couldn't, not after what they had said when I left with Fyre. I closed my eyes to make the blood go away, to try and make the high come down. I loved walking through walls and over air. Why couldn't every high be like that?

When I opened my eyes, I felt Fyre's arms around me, and a little light met my eyes. I could smell his warm scent wash over me. Our black down comforter was wrapped around us,

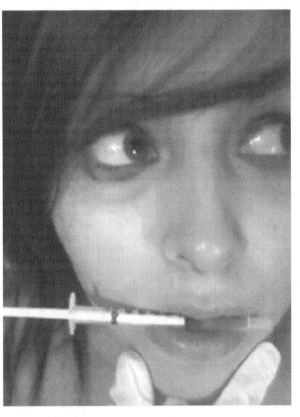

and at least half of the many pillows I usually kept on the bed were strewn about the floor. The black shades covering the windows blocked out sunlight exceptionally well. They created a false night for us late into the morning. Rolling out of Fyre's embrace, I sat up and leaned back against the headboard. My head hurt intensely. It felt almost as if I had fallen face first onto a linoleum floor. Massaging it gently, I felt Fyre's hand wrap around my wrist. He wanted me to lie down again, but I was awake now. I

looked at the back of the bedroom door and began to count the number of syringes that I'd emptied into my veins only to throw at the back of the door. Fyre's voice pulled me away from my counting as he asked me what was wrong. I told him about the pain in my forehead. He stretched and sat up as well, looking at me concernedly.

"Does it really still hurt?" he asked. "I guess that you ran into the wall pretty hard last night." I couldn't understand, so I asked him of which wall he spoke, as I'd only walked through walls last night, not into them.

"No, you walked right at the wall and..." here he punched his fist into his open palm, "wham! You fell backwards, so I caught you and placed you on the bed until I was ready to go to sleep. You've been out for quite awhile."

Fyre took my face between his hands, and he softly pressed on different places around my forehead. Happy in that there were no signs of breakage or tenderness save the bruise where I'd made contact with the wall, he removed his hands and got out of bed. My skull seemed to be in one piece. He smiled his satisfaction and began to speak to me.

"You seem fine, love. You've got quiet the coconut head there." He laughed quietly as he walked over to my side of the bed.

I didn't laugh with him, though. I'd been told that before, and right now my head was pulsing too much for anything to seem remotely humorous. He took my hand and led me to the kitchen where he gave me a couple of Advil and made breakfast for us. A television program about poppy seeds was playing on the 42 inch. I sat next to Fyre as he watched with interest. The program said that the first painkillers came from the morphine made with poppy seeds. I found it fairly intriguing once the pain had subsided. Not nearly as interesting as breakfast, though. While we ate, he asked me what I'd seen yesterday, so I described to him why I'd been so restless in my drug-induced sleep.

"I think that you should go and visit your sister," he told me when I was finished.

Was he crazy? There was a good reason why I hadn't spoken to my family in two years. My parents were so proud of my sister, and I was certain that they doted upon her daughter. But me? I disregarded everything that they had ever taught me, shoved everything that they'd given to me back in their faces. Now Fyre, the only one who they ostracized more than me, was suggesting that I go visit them? The answer was no.

"But love, you don't have to see your parents. Just go see your sister and meet your brother – in –law. Aren't you the least bit curious about your niece?" He would have to do better than that to change my mind. After about an hour of this though, Fyre had worn me down, and I finally agreed to go. The catch was that he had to accompany me.

That is why I am now sitting down to a very awkward Sunday dinner with my sister, her husband and Fyre. My sister is just as bright and bubbly as ever. She doesn't even seem to notice that this is an uncomfortable meeting. She prattles on about Noel, my niece, and how well her husband is doing at work, as if he couldn't tell me himself. After telling me everything she can think of presently, she turns her gray eyes on me. They meet my dark blue ones in a tentative stare. Her thin ribbon lips spread into a smile that dominates the mood, and she is silent for the first time since I arrived.

"So tell me, when you're not working on art, what is it that you do," she asks me, "you know dear, in your spare time?"

I ponder my answer for but a moment, and as I'm not feeling very open right now, I tell her exactly what I did last night, "I run into walls."

My family and I aren't getting along perfectly, but making a bridge between my sister's family and mine is a good place to start. I absolutely adore my niece, and even though the first step was hard, now it's over, and I know that this isn't the end. Next weekend Fyre and I are going to meet my sister's family for lunch and go to see a matinee showing at a movie theater. After that we'll just have to see where it goes. I'd love to watch Noel grow up, and that's just what I intend to do. While chaos still buzzes around me, I have found what I'd been trying to make up for since I left those who truly care for me. Peace.

Rain, Rain

Poetry by Megan Beery, Junior
Photoshop by Kate Smith, Senior

Rain, Rain
come to stay.
You're the only one who can
wash my pain away.

I stand with you
beside me, behind me
and above; you're the
closest thing I have to love.

Ignorant people walk past;
they have love that will not last,
Raise umbrellas to keep you out,
they don't know what you're about.

You smell so pure
and feel so clean,
make right all
that is obscene.

I wait alone for you to come.
You always said I'd be the one
that you'd catch and hold for all time.
How I wish that you were mine.

Yet you have work to do,
for during the night you
make all that was old new
and everyone else hasn't got a clue.

I'm the one you're
with all day; I tell
you to go ahead, rain on my parade.
For you I completely fell.

Still standing among those
who don't know you, I know
they think I'm strange. They're right.
I'm not like them. As I say yes, they say no.

I let you wrap yourself around
me, run through my hair, down
my back and to the ground.
You touch my face and you'

soft as lace.
All my features you trace,
all the colors you taste,
for you've got no color of your own.

Your presence is a comfort.
It soothes my foul mood, gently
peels away my bad attitude,
and brings out for all to see,
the very best of me.

Rain, Rain
come to stay.
I feel you're here like tears to drown;
you found all I've lost and love me anyway.

- The F Words -

A Dandelion Among Roses

A hummingbird flowing through the crowds,

She's a chameleon, being just what people want her to be.

Every day the vultures circle above her head,

Waiting for her to break down.

You never hear a complaint from her velvet lips,

Simply her clean, masked, silk voice

As she carries on this charade,

Poetry by Chantell Cooper, Sophomore

A dandelion among roses,

Seen for the wrong reasons.

Charcoal by Nicole Noland, Senior

She wishes to have the bravery of a tiger,

To be who she really is.

Her gem eyes, a stunning jade color,

Hold such sorrow and pain.

No one sees her crimson rose red scars;

She keeps them hidden

And later adds to them.

Is she forever destined to remain the owl hiding in endless darkness?

Will she forever remain the painted picture she is now?

If for one day she could be the beautiful eagle,

Soaring comfortably and confidently through the sky,

Only to return to the delicate dove,

Forever remaining the dandelion among roses.

THE NATIONAL ENQUIRER

February 12, 2010

Bat Boy Leads Cops On 3 State Chase

Fiction by Jessica Verkler, Senior
Scholastic Writing Certificate of Merit

I was born Damien Joe Fester. Later on in life, I would be rechristened Bat Boy, but that's a part I'd rather not get into. I'm telling this story from a maximum security prison. Currently, I'm taking a little stay in solitary confinement. It gives me a lot of time to think. I figured I'd spend my time contemplating how I got in here and whether or not what I did was right...

Like I said, I was born Damien Joe Fester. I lived in the upper peninsula of Michigan in a town called L'Anse. It was cold, boring, and full of awful people. I thought the cold made them mean, but when I left Michigan, I found out that people were the same everywhere, no matter the weather conditions.

Believe it or not, when I was born, I looked normal. Some might even say I was cute. But as I grew older, my appearance began to warp. Up until the age of three, I looked fine. Then things started changing. It began with my eyes. They just started growing. My mother told me that one morning when she went to wake me, she noticed my eyes were much larger than normal. The next day, they were even bigger. She had no clue what to do; she almost thought it was just her imagination. She took me to the doctor anyway, but there was nothing he could do for enlarging eyeballs. After a week, my eyes were bugging out of my head. My mother was horrified. She had no idea what was happening to her baby. My mother has always been very concerned with appearances, so this was probably mortifying to her. She went from having a cute toddler to a freaky looking kid. But if the eyes weren't enough, my ears and teeth surely put her over the edge. Shortly after my eyes mutated, my ears started changing. She just noticed that my tiny little ears had started growing points on the end. Over time, the points grew more defined. By that time my mother was at wit's end. She wanted a normal baby. I was anything but a normal baby.

My teeth were the final straw. One Sunday afternoon in April, I took a bite out of a Granny Smith apple. I chomped down into the apple, and all my teeth were pulled out. All of them. Two weeks later, all my teeth came back, but they weren't teeth. They were fangs. At that point, a change came over my mother. She became very quiet and withdrawn. I feel that it was my fault. If I'd been normal, she wouldn't have had her breakdown. She didn't know what was wrong with me. I was the weirdest, ugliest kid ever born. I had bulging eyes, pointy ears, and fangs. It was disgusting. I was disgusting. Nobody, not even my mother, could stand the sight of me.

When school started, my problems multiplied. Mother tried to keep me out of school as long as possible. When I started school, I was already a year older than all the other kids, but my extra age didn't matter. The kids, those little kindergarteners at L'Anse Elementary, already knew how to be cruel. They picked up on me right away. It's hard to miss a kid who looks like me. First, they teased me and called me all sorts of names. They shoved me around at recess. They knocked over my block towers and took away my snacks. It may not seem like bad things, but to me, at that age, it was terrible.

Once I started first grade, I started getting sick. I was shunned by everyone at school, and even my teachers looked at me with disgust. It was just because I was so scary-looking. People didn't understand me. They didn't see that inside I was human just like them. But anyway, back to getting sick. I couldn't stand school. I hated it. It was a living hell for me. So I started to fake being sick. My mother, who just wanted me to be happy, went along with it. I knew she didn't believe me, but she knew what school did to me. So she would let me stay home. By first grade I had earned my nickname of Bat Boy. I don't even remember how it happened. I just remember one day I came to school and I had been dubbed Bat Boy. It's a pretty lame story, but that's

how it went down.

The abuse I suffered in kindergarten continued all through elementary school. I was bullied, teased, called all sorts of names, and shunned by everyone. I would say the shunning was the worst, but being embarrassed everyday in school wasn't fun either. I hated both equally. As the

Pencil by Kate Smith, Senior

years went on in elementary school, the abuse got worse. I tried my best to hide it from my mother. Poor mother. She grew more and more weary every year I was in school. It killed her to see me so unhappy. But there was nothing we could do to change the situation. I couldn't switch schools because I was sure people would treat me the same no matter where I went. We didn't have money for a private school. Homeschooling was out of the question because my mother was

the only source of income we had. Oh, I haven't mentioned anything about my dad, have I? Well, that's because I don't know who my dad is. Mother tries her best not to say much about him. Apparently, he wasn't the greatest guy. So it's just my mother and I. It always has been.

Anyway, I was stuck at the school I was going to. My mother knew what was happening to me, and it really hurt her inside. I tried my best not to show it, because I didn't want her to be sad as well. It got harder as the years went on. I grew bigger and stronger than my peers, but I wouldn't hit them. I just couldn't. Go figure. I'd come home with bruises, but I'd tell my mom it was from gym class and from falling over. Who knows if she believed me?

When middle school started, things stayed the same. I got beat up, teased, or shunned. I guess it just depended on how the rest of the student body felt that particular day. Needless to say, I had some issues. I was depressed and scared to go to school. I was only

happy at home because it was safest. So how did I make it through the days? What kept me going? Well, even if you don't care, I am going to tell you about her anyway. Her name was Lily Smith, and she was the only girl I have ever, and *will* ever, love.

You may think I'm being over-dramatic, but I'm not. I really did love her. She was the only person I ever met who treated me like a person. She didn't cringe when I was near her or shy away. She never teased me or called me Bat Boy. She didn't ignore me like everyone else. She was genuinely nice to me. I don't know if she ever knew how much she meant to me. I wish I had told her, but at that time it was out of the question. We weren't exactly friends, but she was the closest thing to a friend I had. It's hard to be friends with someone you're terrified to talk to. At first I had trouble deciding if she was just trying to make herself look good or if she was genuinely nice. But after awhile, I knew it was the latter. She would do things she didn't have to do, like let me sit at her lunch table. She would talk to me in class. If she saw me in the halls, she would speak to me. It was really nice, and Lily made me feel like I actually belonged with everyone.

I suppose if I'm going to go on and on about Lily, I should tell you what she looked like. That

way you know just how beautiful she was, inside and out. She was shorter than average, with slightly wavy, blonde hair. She had bright green eyes that shined like a wet lime. Yeah, that's right, a wet lime. She had a heart-shaped face with pale, smooth skin. It wasn't an unhealthy pale. It was a natural pale, and I couldn't imagine her any other way. She was slim, and her favorite clothes were T-shirts and jeans. She was amazing. She had an infectious laugh, and she loved animals like nobody I'd ever met. Maybe that's why she liked me, ha ha.

Anyway, despite the kindness that radiated from her, my life was still difficult. Although I loved Lily very much and appreciated her kindness, I envied her at the same time. I thought her life was perfect, and was angry at how dismal and depressing mine was. However, I later found something out that changed my attitude about Lily's "perfect" life.

One day, I was down in the nurse's office. I had been pushed down the stairs in gym and my teacher, tired of my injuries, sent me to the nurse for the rest of class. As I was down there with an icepack on my shoulder, I heard a familiar voice waft in. *Lily!* I became very excited. Maybe I would actually get a chance to be alone with her. I imagined the conversations we would

have, how I would show her, right here in the nurse's office, that I was not a monster. I was a human being, an intelligent human being, with feelings and opinions. But Lily did not come in. Instead, I saw her go into the nurse's office. She did not shut the door. Because of my massive ears, I have very good hearing, and I heard their whole conversation. It went something like this:

"Lily, what happened last night? We decided that every day you would come down so I could see if you had any new injuries and I could record them for evidence."

"I know, Mrs. Hughes. The only thing new is the bruise on my arm." I heard a camera turn on, then I heard Mrs. Hughes speak.

"OK. Please lift up your sleeve so I can take a picture."

"Lily, in your own words, how did you acquire that bruise?"

"My dad...pushed me down the stairs."

"OK. Now, I need you to listen carefully. We have plenty of evidence to get you out of your house and place you somewhere else. Don't be afraid, Lily. You're going to be fine. We just haven't been able to do anything just yet. We have to have plenty of evidence before we make such an accusation."

"I understand. I know you guys are looking out for me. Thank you."

"How long has this been going on?"

"All my life."

"You poor girl. I promise, he won't touch you again."

I saw Lily walk out of the nurse's office. Her head was down, and I thought she was crying. Suddenly, I felt like a genuine monster. All my life, I thought I had it so rough. I thought *I* was the only one who suffered. But in reality, Lily was just like me. Except her hell wasn't at school, it was at home. I felt about two inches tall. I felt selfish, greedy, and all other kinds of emotions that didn't make sense. Suddenly, an idea popped into my head. Tomorrow, I was going to talk to Lily. I was going to tell her that I knew what she was going through, even though the location of her pain was different than mine. I wanted to let her know that I would always be there to talk, just like she had done with me. *Tomorrow*, I decided, *tomorrow I will talk to Lily, and I will become the hero she needs*. Little did I know, my glorious day would never come.

I woke up the next morning with a purpose. I knew what I needed to do. I was going to march up to Lily and tell her that I would be there for her. In my head, I pictured her being overcome with gratitude. She would throw her arms around me and tell me how wonderful she thought

I was. I, Bat Boy, would be her hero.

When I got to school, I knew something was wrong. The halls were unusually quiet. Even my everyday harassers didn't come up to me. They left me alone. I passed a group of teachers talking, and my intensified ears picked up one whispered word: Lily. They were talking about Lily. Suddenly, I became panicked. I quickened my pace and raced up to my locker. I passed Lily's in the process. She wasn't there. I saw a group of girls crying, and I made a connection I'd never made before; all of them were friends of Lily's. Without thinking, I walked up to them and asked what was wrong. For a moment I think they forgot who was talking to them. A tall girl with long, red hair answered, "Lily died last night. Her dad killed her."

The words hit me like a flood. I felt my head getting lighter and lighter. I staggered backwards. *It can't be,* I thought, *it just can't be.* I had to get out. I left the school (nobody tried to stop me) and headed back home. My mother was surprised to see me. I opened my mouth to tell her what had happened, but that was too much. I crashed to the floor, and that's all I remember.

I didn't have to go to school the next day. Mother wasn't going to force me. She knew Lily had been special to me,

even though I never told her. I laid in bed and stared at the ceiling. I finally had something good in my life, and it was gone. Lily was gone. I cried for hours, then I stopped crying. Then I cried again. It went on and off all day.

Later that night, as I laid in bed, a thought crept into my head. Throughout the course of the day, something inside me changed forever. Some would say it was the grief; some would say that I'm just crazy. But a hatred began to boil up inside me for Lily's father. I hated that man. I hated him so much. How could he hurt a girl like Lily? She was the sweetest, most compassionate person. How...how could he? She was his *daughter*. My head hurt from the pain I was feeling inside. Suddenly, an idea popped into my head. A terrible idea, but to me, it was justified. I was done living here. I was ready to move on. I had no reason to stay, and my mother would be better off without me. It was settled. I was going to kill Lily's dad.

The next day I planned. I knew Lily's dad had made bail. It had been in the papers. I hoped he would be at home. I wouldn't have known where else to look. All day I sat in my room and cleared my mind. Later, I waited to make sure my mom was asleep. Then I went into the kitchen and found the biggest knife we

- The F Words -

had. The blade was about 8 inches long. It was perfect. I put it in my backpack and walked out the door.

I needed a way to get to Lily's. I was going to ride my bike, but I thought that would draw too much attention. I'd be riding my bike in the dark; I didn't want any more attention than was necessary. Plus it was me. I'd draw attention no matter what. I decided to take my mom's Prius. It was very quiet when it started, so it seemed like a perfect idea at the time. I jacked her keys in the garage and started the car. Then I opened the garage door and backed out.

On the other side of town was Lily's house. I drove there and parked across the street, where I began my watch of the house. The funny thing was, I wasn't scared. Not at all. I wanted to do this. All my life, I had been called a monster. Yet this man beats and murders his own child, and until then everyone thought he was a great person. All because he *looked* normal. I watched the house. The lights were on, and I could see everything. Suddenly, I saw someone move. It was him.

I got out of the car and went towards the house. I hid behind a bush and watched him. He sat down at a table. He didn't even look sad. How could they let this monster out? I

knew it was now or never. I didn't really have a plan; I just knew what I had to do. I ran up to the front steps and rang the doorbell. I wasn't sure if he would answer, but soon I heard footsteps. He was coming. *Crap!* I thought. *What am I going to do? The knife isn't out and ready. I don't have a plan!*

The door abruptly flew open. A man of about 40, with the same blond hair and green eyes as Lily, answered the door. He stood there with this weird look on his face. I'm sure I'm a sight for anyone not used to me. Finally, he said, "Can I help you?"

"Uh...yeah...do you....uh...can I use your bathroom?"

The monster paused. "Sure, down at the very end of the hall."

I entered the house where Lily had lived. I tried to imagine what she had gone through everyday. I realized I was staring, so I ran down the hall to the bathroom. I went inside and closed the door, then I pulled the knife out. I sat down on the floor and started thinking of what I would do. I would go out, and I would rush him. I'd stab him and make him suffer like he did to Lily. I heard a knock at the door. "Are you OK in there?" I heard the voice ask. "I want you to leave now."

I had the knife in my hand. I counted to three, then I threw the door open. He never saw it

coming. I stabbed him in the upper chest, and he stumbled. He yelled at me, but I stabbed him again. And again. And again. I didn't even realize what was going on. When I was done, I stood looking around. Blood was

Charcoal by Meredith Rogers, Sophomore
Scholastic Art Gold Key Award

everywhere. I couldn't believe what I had done. But I felt different inside. I was a new person. I would never be the same boy who loved Lily. I heard sirens in the distance, and I knew they were for me. I wasn't ready to give up without a fight. I ran outside and jumped in the car. I did this for Lily. I hoped she appreciated what I'd done. I was content knowing that Lily was in a safer place, and her father, well, there's a special place for people like him. I drove away as

the sirens roared behind me...

~ ~ ~

Now you know why I did what I did. After killing Lily's dad, I led the cops on a three state chase. It was epic, but it ended in Ohio. I didn't

give up without a fight though. I may be in prison for life, but I did it for Lily. I did it all for Lily, and I wouldn't change a thing. After I was captured, the media got ahold of my story. They called *me* a monster, but how foolish they were. They wouldn't know a real monster if they saw one. Some may think what I did was a waste, but it was the least I could do for the girl who made my life worth living. I will live out the rest of my life in here, and it won't ever bother me.

Tough GUY

Prose by Kayleigh McMichael, Senior
Photo by Kate Smith, Senior

"I LIKE TO HIT WOMEN," a tiny voice piped up, as a gappy smile of missing teeth spread across the eight-year old boy's freckled face. My blood suddenly started circulating in the other direction, pumping as if it were trying to out run the storm of anger that began to well up in my chest like a funnel cloud. I tore my feet from the ground to spin toward that sneaky face of brown specks; the carpet nearly ripped under my heavy, livid change of movement.

My palms bounced away from my sides as adrenaline swarmed through my fingers. I fixed my deadened eyes on him with a stern, "NO." I couldn't help but feel the responsibility to discipline his evil-prodded comment. "You DO NOT lay a hand on a woman." My finger sprung away from the others, pointing forcefully in his direction.

A stubborn little boy, thinking of himself as having the power of God, was so clearly masked on his grin.

"EVER," I added in a tone so dark that even a boy with his disrespectful, heathen complex recognized that I was serious. The blue carpet became more shadowed with stuffy starchiness than before. I was standing in the same hallway I once did ten years ago, my words enveloping and petrifying every wooden classroom door in anger.

The array of freckles re-routed their pattern as his face dropped in astonishment. He stood slightly slumped on a brown, homemade box in front of the drinking fountain. Other kids went around him, anxious for the water to quench their playground thirsts. He stood still for a moment as my right, index finger remained stabbed in his direction.

I let that moment sting in the pit of his stomach before turning back around to continue escorting my second-grader to the restroom. It killed me to imagine where his "values" stemmed from; some chauvinistic father figure? I hoped not. I really hoped not. The beads of a calm shiver stimulated my skin as I walked toward a sign that read "WOMEN," and a small female hand gripped mine, with the word "Ever..." echoing in my head.

I awake with eyes full of wonder
Going faster in the stream as

The four quarters pass
And the earth changes from

White to green and back again
With unceasing precision

My core is opened to a prickly devil
Who misuses the device so precious

And talks with two heads
So misleading and never understanding

Thus it ended as it began
Only to start anew with a finer devil

I take a stupid path
The brave and the foolish take

The Other Side of the Gate

Poetry by Adam Kickbush, Sophomore
Charcoal by Nekodah Niedbalski, Senior

Impossible to navigate
The prize inaccessible

Dejected I wander aimlessly
Unable to escape or endure the path

A house in the distance
Majestic to some outside gates of duplicity

I am ushered forward by a man with golden
features
Who flashes his smile suppressing snakes

A rotten hovel on the inside
With a flight toward light

I walk up the lonely stairs
To talk to the dry bones

Who rattle back their reply
With a need to impress

With no exit to be seen
I prattle my parry

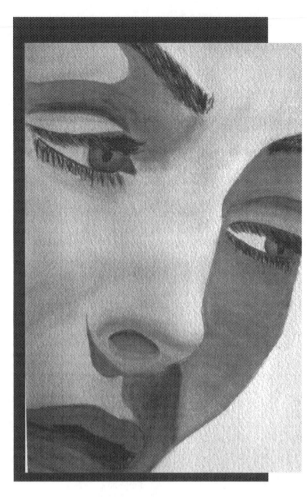

Jump

Jump

Jump

Poetry by Sarah Knowlton, Junior
Watercolor by Mitchell Keen, Junior

I.
Summer time at Ouzel Falls.
Rushing waterfall, a rickety tree has fallen.
She stands there; the tree is slippery.
With a deep plunge beneath her,
Her thoughts rush
Just as the Falls before her.

II.
She is in Italy, with her love.
They dance in the moonlight.
Soft whispers fill the air around them,
But she can not hear them
For she is in love.

III.
On the mossy log,
She thinks of him
And how his beautiful face
Was once hers.

IV.
For the last time she sees him.
Her heart is shattering.
Italy has never seemed
So much like the burning pits
Of Hell.

V.
He is there,
Behind the beautiful foliage,
Looking at her in love.
He says, "I'm sorry and I love you,"
As she jumps to her death.

- The F Words -

The Photograph

Poetry by Nathan Gardner, Senior
Watercolor by Allison Adkins, Senior

Out the window, a dark peace.
The snow is falling.
Feelings lash at my soul
As icicles pierce my heart.
I am falling asleep in front of the window.
I wake briefly and snap a photograph,
The brutal landscape of winter,
The first Christmas without you.

Razor Sharp

Poetry Renga by Megan Snyder, Kelsey Piotrowicz,
Jessica Verkler, and Kate Smith
Charcoal by Chloe Bugajski, Senior

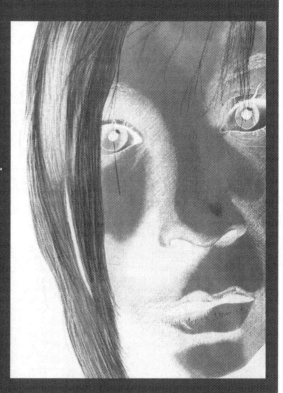

Razor sharp are your words as they cut through me,
Screaming through my veins,
The angry bullets of furious energy.
I yell and shriek and screech
All the horrible lyrics to this furious song in my head.

Swords of the past
Cut sharp into the never-ending present.
Your eyes pierce mine in the dark abyss of my dream.
I run in a furious haze,
Trying to find where I left my mind.

Anger sears my heart like a hot knife.
When I look at you,
I go into a mental frenzy.
You torture me every minute of the day.
Do you even realize what you do to me?

Stop it! Stop,
Before I break out of this cage and fight back!
Right now I'm only growling,
But I'll break out with razors sharper then yours
If you don't cease.

C O N T R I B U T O R S

Footnotes